GEORGIA O'KEEFFE
CIRCLING AROUND ABSTRACTION

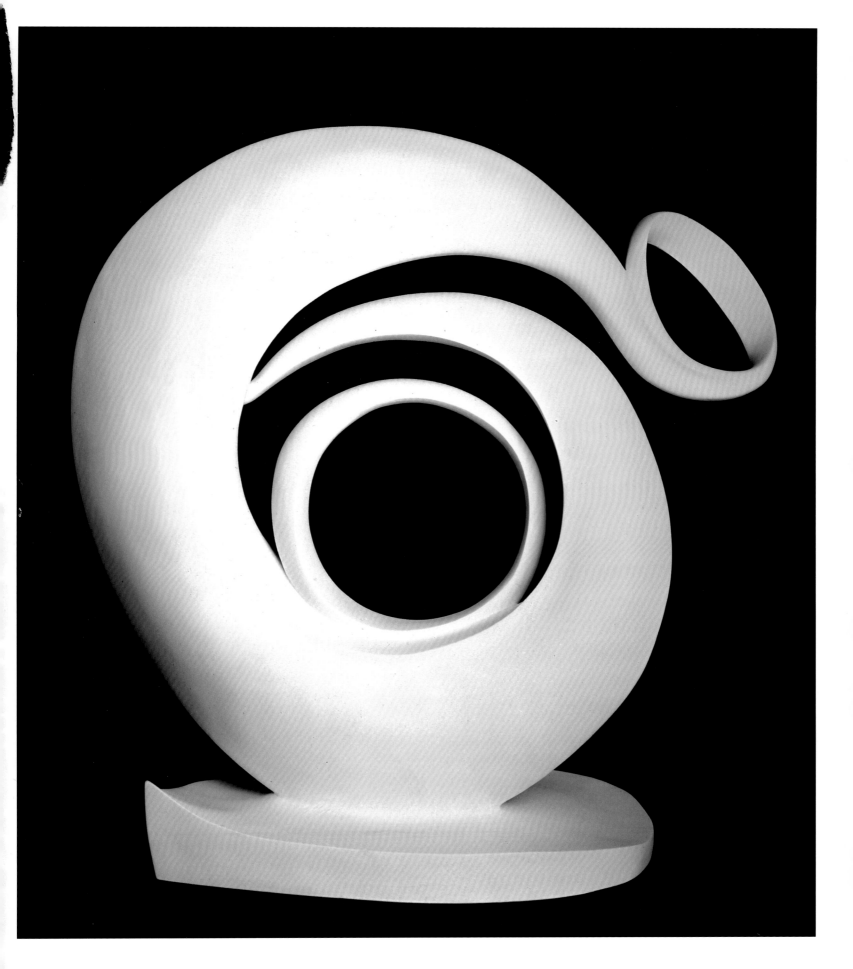

ESSAYS BY JONATHAN STUHLMAN AND BARBARA BUHLER LYNES
NORTON MUSEUM OF ART, WEST PALM BEACH
IN ASSOCIATION WITH HUDSON HILLS PRESS, NEW YORK AND MANCHESTER, VERMONT

GEORGIA O'KEEFFE
CIRCLING AROUND ABSTRACTION

Georgia O'Keeffe: Circling Around Abstraction is published to accompany the exhibition of the same name, originated by the Norton Museum of Art, West Palm Beach, and on view there from February 10 through May 6, 2007, and traveling to the Georgia O'Keeffe Museum, Santa Fe, from May 25 through September 9, 2007, and The Minneapolis Institute of Arts, from October 7, 2007 through January 6, 2008.

First Edition © 2007 Norton Museum of Art
1451 S. Olive Avenue
West Palm Beach, Florida 33401

Published in association with Hudson Hills Press LLC, 3556 Main Street, Manchester, Vermont 05254. Distributed in the United States, its territories and possessions, and Canada by National Book Network, Inc. Distributed outside North America by Antique Collectors' Club, Ltd.

Executive Director: Leslie van Breen
Founding Publisher: Paul Anbinder

Coordinator and Editor: Terry Ann R. Neff, t.a. neff associates, inc., Tucson, Arizona
Designer: Studio Blue, Chicago (www.studioblue.us)
Printed and bound by: Conti Tipocolor Arti Grafiche, Calenzano, Florence, Italy

Library of Congress Cataloguing-in-Publication Data
Stuhlman, Jonathan.
Georgia O'Keeffe : circling around abstraction / organized by Jonathan Stuhlman ; with essays by Jonathan Stuhlman and Barbara Buhler Lynes. – 1st ed.
p. cm.
Published in connection with an exhibition held at the Norton Museum of Art, West Palm Beach, Georgia O'Keeffe Museum, Santa Fe, and Minneapolis Institute of Arts, 2007-2008.
ISBN-13: 978-0-943411-49-1 (alk. paper)
ISBN-10: 0-943411-49-1 (alk. paper)
1. O'Keeffe, Georgia, 1887-1986–Exhibitions. I. Lynes, Barbara Buhler, 1942- II. O'Keeffe, Georgia, 1887-1986. III. Norton Museum of Art. IV. Georgia O'Keeffe Museum. V. Minneapolis Institute of Arts. VI. Title.

ND237.O5A4 2007
759.13–dc22
2006036053

Frontispiece: Georgia O'Keeffe, *Abstraction*, 1946 (cast 1979/80; plate 41)

THE TRUSTEES AND DIRECTOR OF THE NORTON MUSEUM OF ART
GRATEFULLY ACKNOWLEDGE MRS. SHELBY CULLOM DAVIS
WHOSE EXCEPTIONAL VISION AND GENEROSITY
MADE POSSIBLE GEORGIA O'KEEFFE: CIRCLING AROUND ABSTRACTION

FOREWORD CHRISTINA ORR-CAHALL, DIRECTOR

During the 1970s, when Georgia O'Keeffe came to Palm Beach to see her sister, she visited the Norton Museum of Art. I believe the museum provided the artist with a welcome respite and escape from the island's social whirl. As the Curator of Collections at the time, I would be asked by the Director to escort O'Keeffe through the building. The first time I met her, it was with great trepidation: I had no idea what to expect or how I would be received. She seemed physically smaller than I anticipated, but far from frail, with a weather-tanned face. By way of introduction, I mentioned that we had attended the same strict boarding school, which had changed little between the years we were there. We commiserated over our shared experience. As we walked through a gallery in which two of her paintings in our collection were hanging, she made some brief remarks about how good it was to see them again, but she was most interested in the work of her friends hanging alongside. She reminisced about Dove, Hartley, Demuth, and others, admiring and even remembering in some cases when she had first seen each work in New York. One of my most memorable recollections – an instance of her remarkable wit and her sense of self – occurred when she turned a corner to walk into a dimly lit gallery. I remarked: "Miss O'Keeffe, there is a photography exhibition in that space." Without missing a beat and in a strong, even voice, she responded: "You know, my husband was a photographer."

Given the challenges O'Keeffe faced as a woman artist – to be accepted on the same level as her male peers, to set her own track with her own style, and to work unhindered by traditional familial constraints – it is no wonder that she has been seen as a pioneer and role model for other female artists. O'Keeffe's paintings are perennial favorites with the Norton's audience. Even during her lifetime, her images of sumptuous flowers and arid desert landscapes had become a familiar part of American visual culture. In 2005, when the Norton hosted *In the American Grain,* an exhibition of work by the artists in the circle of Alfred Stieglitz, the comment books confirmed that O'Keeffe's paintings were the overwhelming favorites of our visitors.

Although the Norton is fortunate to own three paintings by the artist, *Georgia O'Keeffe: Circling Around Abstraction* is the museum's first exhibition dedicated entirely to her work. It follows in the tradition of projects that enhance the interpretation of the Norton's collection, make insightful contributions to scholarship on a national level, and bring important works of art and engaging educational programming to our region. By assembling more than forty of O'Keeffe's paintings – which is no small task in and of itself – *Georgia O'Keeffe: Circling Around Abstraction* will illuminate an important and underexamined aspect of her work, thereby shedding new light on O'Keeffe's contribution to the history of American art.

This exhibition was conceived by Jonathan Stuhlman, formerly the Harold and Anne Berkley Smith Curator of American Art at the Norton Museum of Art. During a courier trip to the Georgia O'Keeffe Museum in Santa Fe in the summer of 2004, he saw the monumental version of *Abstraction* (1946, cast 1979/80), one of the artist's rare sculptures; its hypnotic, spiraling form called to mind the intense blue sky encircled by the sockets of a pelvis bone in the Norton's own *Pelvis with the Moon–New Mexico* (1943). As he began to explore the formal connections between these two works, he came to realize that circular forms played an important role in O'Keeffe's art throughout her career and that her use of these forms as a pathway to abstraction was an important element in her contribution to American modernism.

From the earliest stages of this complex undertaking, the staff of the Georgia O'Keeffe Museum – particularly Director George King and Curator Barbara Buhler Lynes – have gone out of their way to lend their support. We are particularly grateful to them for their generosity as a lender, for their assistance in locating works of art held in private collections, for their decision to host the exhibition, and for Barbara Lynes's scholarly contribution to the catalogue. The Minneapolis Institute of Arts has also been involved with this project almost from its inception, and we are pleased to be able to include two paintings from their collection in the exhibition, and to share it with their audience as well.

This exhibition is supported at the Norton and on the national tour with generous funding from Mrs. Shelby Cullom Davis. Like O'Keeffe, Mrs. Davis is a woman who walks a distinct path – with leadership in international relations with the Soviet Union, in the art world, and in philanthropy. Educated at Wellesley College, Mrs. Davis is celebrating her one hundredth birthday on February 25, 2007. Her support of this exhibition is part of her birthday celebration, her gift to the communities of Palm Beach, Santa Fe, and Minneapolis, and to the art world at large. I cannot imagine a more generous way to celebrate a centennial. In meeting with Mrs. Davis to discuss this exhibition, I was struck by the parallels to my meeting with O'Keeffe: to the encounter with an incredibly dynamic woman with vast world experience, an intense commitment to art, and a great and quick mind. The Norton Museum thanks Mrs. Davis for making this exhibition possible. We salute her in the achievements and quality of her life, and wish her many more years of vibrant living.

ACKNOWLEDGMENTS JONATHAN STUHLMAN

Considering that Georgia O'Keeffe was something of a loner, who kept only a small circle of trusted friends, it is rather ironic just how many people it takes to produce an exhibition of her work. I am indebted to those listed below for their efforts.

At the Norton Museum of Art, Director Christina Orr-Cahall and Roger Ward, Chair of the Curatorial Department and Curator of European Art, offered continual support, encouragement, and direction from start to finish. *Georgia O'Keeffe: Circling Around Abstraction* is a richer, more engaging, and more complete project as a result of their input and enthusiasm. Their belief in my ideas was inspiring, as was their willingness to tap into their vast network of colleagues and peers, and I have learned a great deal from them both over the past three years. Without the dedication, patience, and persistence of the Norton's Curatorial Administrator Karol Lurie and Registrars Pamela Parry and Kelli Marin, there would be no images in this book and no works of art in the exhibition. This triumvirate has kept innumerable details from falling through the cracks. Others to be thanked at the Norton include Tracy Edling and her staff in Design and Installation, who worked diligently on the installation and graphics; Glenn Tomlinson, Carole Gutterman, and Hannah Dunn in the Department of Education, who created thoughtful and engaging educational programs; Lucy Bukowski, Larry Rosenzweig, Cathy Peters, and Natalie Ellis in the departments of Finance and Advancement, who secured funding and kept the budget under control; Lisa Heard, who attended to myriad other details with grace and efficiency; and the rest of the museum's staff whose hard work has impacted this exhibition.

It has been a pleasure to work with the staff of the Georgia O'Keeffe Museum on this project. Barbara Buhler Lynes, the museum's Curator and Director of the Georgia O'Keeffe Research Center, has answered numerous questions and provided valuable assistance,

advice, and guidance, in addition to her thoughtful and insightful essay for this catalogue. Any O'Keeffe project is virtually impossible without her input, and I feel very fortunate to have been the beneficiary of her support. I also wish to thank Director George King for his early interest and encouragement. Additionally, Heather Hole, Eumie Imm-Stroukoff, Judy Smith, and Dale Konkright have all helped to ensure that various aspects of this project, from research to installation, have gone smoothly, and I am indebted to them for their assistance. At The Minneapolis Institute of Art, Director William Griswold and Curator of Paintings Patrick Noon have been both generous lenders and gracious hosts.

Georgia O'Keeffe: Circling Around Abstraction would not have been possible without the generosity of more than a dozen museums, which have kindly lent their paintings and drawings. We thank our colleagues at the following institutions: Amon Carter Museum, Jane Myers and Rick Stewart; Birmingham Museum of Art, Gail Trechsel; Brooklyn Museum, Linda Ferber (now at The New-York Historical Society), Terry Carbone, and Arnold Lehman; Dallas Museum of Art, Dorothy Kosinski, John Lane, and William Rudolph; The Marion Koogler McNay Art Museum, William Chiego; The Menil Collection, Joseph Helfenstein; The Metropolitan Museum of Art, Ida Balboul, Lisa Messinger, Philippe de Montebello, and Gary Tinterow; Milwaukee Art Museum, Margaret Andera and David Gordon; Museum of Fine Arts, Houston, Peter Marzio and Emily Neff; The Museum of Modern Art, John Elderfield and Glenn Lowry; National Gallery of Art, Judith Brodie and Earl Powell; and at the Whitney Museum of American Art, Carter Foster, Barbara Haskell, and Adam Weinberg.

Numerous private collectors have kindly lent their art to this exhibition as well. I offer my deepest gratitude to Elizabeth and Duncan Boeckman and Katherine Boeckman Howd; Lee and Judy Dirks; Nancy Ellison and William Rollnick; James and Barbara Palmer; Gerald and Kathleen Peters; Donna and Marvin Schwartz; Alice C. Simkins; Marion Swingle; Mr. A. Alfred Taubman; Mr. and Mrs. Romano Vanderbes; and those who wish to remain anonymous. For helping to locate works and for facilitating my interactions with these collectors (and, in some cases, for lending works from their inventories), additional thanks go to Catherine Whitney and Lily Burke at the Gerald Peters Gallery (Santa Fe and New York, respectively); Philippe Alexandre of Alexandre Gallery; Martha Parrish of Martha Parrish & James Reinish, Inc.; Vivian Bullaudy and Hollis Taggart of Hollis Taggart Gallery; Debra Wieder of Hirschl & Adler Galleries, Carol Irish of Carol Irish Fine Art, Inc.; Elizabeth Goldberg of Sotheby's; and Jon Boos and Cheryl Robledo.

During the evolution of this exhibition, many curators, scholars, and colleagues helped shape the concept of the show and acted as sounding boards for ideas. I wish to thank especially Barbara Haskell, Judy Lopez, Lisa Messinger, Elizabeth Turner, Bruce Weber, and the inimitable Kevin Sharp.

It has been a great pleasure to work with Studio Blue on the design of this catalogue. Tammy Baird, Erin Bauman, Kathy Fredrickson, Renate Gokl, Carolyn Heidrich, Maggie Lewis, and Cheryl Towler Weese have listened patiently and developed designs that were thoughtful, elegant, and sensitive to both the concept of the exhibition and the artist's aesthetic. Their flexibility, dedication, and professionalism were always evident and very much appreciated. In a like manner, Terry Ann R. Neff served as much more than the catalogue's editor as she patiently pulled a vast number of details (and individuals) into concordance and worked her magic upon the text. If my prose is half as elegant as the images in this book, it is thanks to her careful eye and gentle guidance.

Finally, I would like to thank my wife, Megan, and (over a briefer time) my year-old son, Justin, who have provided me with support, encouragement, laughter, and inspiration over the three years that I have had "Georgia on my mind."

CIRCLING AROUND ABSTRACTION JONATHAN STUHLMAN

CUT DOWN AND OUT – DO YOUR HARDEST WORK OUTSIDE
THE PICTURE AND LET YOUR AUDIENCE TAKE AWAY SOMETHING TO
THINK ABOUT – TO IMAGINE. FREDERIC REMINGTON, 1903[1]

Frederic Remington's no-nonsense description of the process of making a painting encapsulates one of the central concepts of modern art: a drive toward clarity through the use of reduction, distillation, and simplification. Such a directive might have been issued by any number of twentieth-century modernists, from Piet Mondrian to Mark Rothko, but the fact that they were penned by America's favorite cowboy artist is rather surprising. It speaks to just how early a point in time such ideas were in play and to how widespread they had become. It also says something important about the intellectual and artistic climate that was already in place in this country during Georgia O'Keeffe's formative years as an artist and can, perhaps, help to shed light on her approach to abstraction.[2]

While it may be difficult to think of Remington as a modernist or to consider one of his late nocturnes from this new frame of reference, it is equally challenging to view O'Keeffe's *Abstraction White Rose* (plate 22) – a painting in which she has eliminated everything but the blossom's swirling center – as an "abstraction" rather than a white rose. But through the act of "cutting down and out," O'Keeffe pushed such pictures toward abstraction, generating a dual reading acknowledged and reinforced by her choice of title. Despite her consistent, career-long experimentation with abstraction, the urge to pigeonhole O'Keeffe as a painter of flowers, deserts, or floating cow's skulls, to fall for the seductive surfaces and colors of her paintings, or to be absorbed by things that are either comfortingly familiar or are perceived as "American," continually threatens to obscure one of her important contributions to twentieth-century American art.[3] Indeed, O'Keeffe's radical isolation, simplification, enlargement, and cropping of her subjects – approaches that were a consistent part of her artistic vision and in combination represent her personal language of abstraction – were utterly unique when she first introduced them in 1915, and remained so throughout her career.

One key element of O'Keeffe's abstraction that distinguishes her not only from her European peers but also from the vast majority of American modernists was her consistent use of pulsing, spiraling, swirling circular forms.[4] Although such forms did function as

Fig. 1 John Twachtman, *Edge of the Emerald Pool, Yellowstone*, ca. 1895
Oil on canvas; Spanierman Gallery, New York

Fig. 2 Robert Delaunay, *Disque simultane*, 1912 – 13
Oil on canvas; Private Collection

Fig. 3 Georgia O'Keeffe, *Abstraction White*, 1927
Oil on canvas; Private Foundation, 1997, on extended loan to the Georgia O'Keeffe Museum, Santa Fe

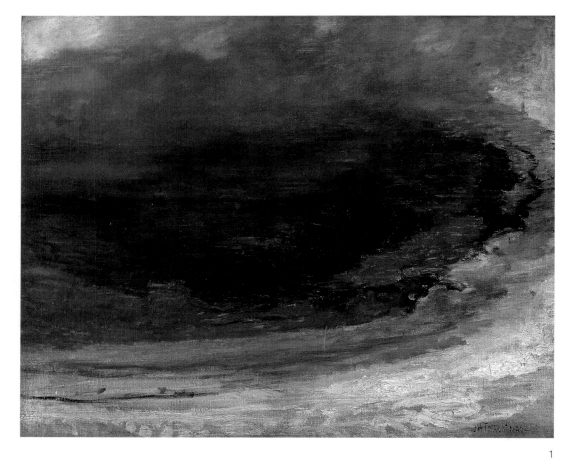

1

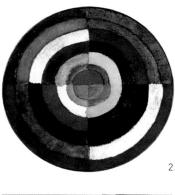

2

3

a pathway to abstraction in other artists' work, from the American Impressionist John Twachtman to the French modernist Robert Delaunay (figs. 1 and 2), O'Keeffe drew upon and returned to this motif more consistently than any of her peers. And while circular forms do not exclusively define her wide-ranging experiments with abstraction – as revealed by a comparison between *Abstraction White Rose* and *Abstraction White* (fig. 3), both painted in the same year, they do constitute perhaps the most innovative aspect of her experiments in this genre. Indeed, O'Keeffe developed an entire vocabulary of circular forms, which emerged from a combination of the subjects that she chose to paint, a wide variety of artistic influences, and her own independent vision.

THE ABSTRACTION IS OFTEN THE MOST DEFINITE FORM FOR THE INTANGIBLE THING IN MYSELF THAT I CAN ONLY CLARIFY IN PAINT. GEORGIA O'KEEFFE, 1976[5]

As Elizabeth Turner and Marjorie Balge-Crozier eloquently demonstrated in *Georgia O'Keeffe: The Poetry of Things*, O'Keeffe's art, no matter how closely it flirts with abstraction, is always rooted securely in the *thing* that she was painting.[6] Thus, while many of her paintings are intended to be read as abstractions *of* her subjects, they are never nonreferrential or *without* a subject. Indeed, O'Keeffe's entire artistic approach was inflected by her tireless desire to amplify and intensify the subjects that she chose precisely because they were interesting to her.

O'Keeffe's consistent desire "to fill space in a beautiful way" – a goal inspired by the teachings of Arthur Wesley Dow – dates from the very beginning of her career and suggests that her early training and influences impacted the development of her distinctive form of abstraction.[7] Dow's approach, informed by his knowledge of Japanese art and design, was fundamentally different from that of O'Keeffe's earlier instructor at the Art Students League in New York, the inimitable William Merritt Chase, for whom she produced skillfully executed but rather traditional works. At this time, around 1908, Chase emphasized the craft of painting in his classes – often giving virtuoso demonstrations for his students in which he painted dark, viscous still lifes of fish. But while O'Keeffe certainly learned a mastery of her materials from Chase, she felt that something was missing from his approach. She later recalled that Dow's method gave her "something to do" with the foundation laid by Chase, and inspired her to "fill space in a beautiful way."[8]

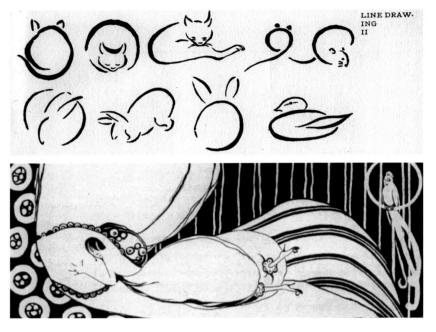

Fig. 4 *Line Drawing II: Brush Drawings from Japanese Books*
From Arthur Wesley Dow, *Composition* (Garden City, New York: Country
Life Press, 1913 [reprint of 1899 edition]), p. 19

Fig. 5 Georgia O'Keeffe, *Untitled (After The Ball Is Over)*, ca. 1916
Published in *Vanity Fair*, November 8, 1916, p. 41

One of the most liberating aspects of Dow's lessons was his method of giving students choices of what to do with the progressively complex aspects of design that he taught them. This empowering emphasis on each individual's creativity resonated deeply with O'Keeffe's independent temperament; she referred to the importance of such choices when speaking with Katherine Kuh decades later in the 1960s.[9] So far as Dow's influence on O'Keeffe's use of circular forms is concerned, his influential book *Composition* contains examples of sweeping, spiraling designs throughout, from the shrouded head of a Gothic sculpture of Mary to the form-fitting shapes ornamenting Rhodian plates to subjects drawn from the natural world, such as a series of Japanese brush drawings of animals (fig. 4). Furthermore, by encouraging his students to employ a tondo (circular) format as well as the traditional rectangle, he emphasized the idea of nonrectilinear design.

The flattened, compressed space and simplified forms – commonly cited hallmarks of modernism – of O'Keeffe's most abstract paintings and drawings were likely inspired as much by Dow's teachings as by her firsthand experiences with modern art. His methodology provided a structured framework into which O'Keeffe could integrate her early exposure to Art Nouveau while a student in Chicago, which was likely one of the first visual stimulants for her lifelong interest in spiraling, organic forms.[10] In *Becoming O'Keeffe: The Early Years*, Sarah Whitaker Peters carefully examines O'Keeffe's possible exposure to Art Nouveau, but it is important to reiterate here the importance of this international movement for O'Keeffe's aesthetic sensibility. For while it may seem easy to dismiss Art Nouveau's influence by the time of the Armory Show in 1913, and to discredit it as a passé visual language overwhelmed by the fractured planes of Cubism and the sleek forms of skyscraper modernity, O'Keeffe's artistic training coincided with the moment of the movement's broadest impact on American visual culture.

O'Keeffe's most direct experimentation with Art Nouveau is found in the images she created for commercial reproduction (which were published contemporaneously with her earliest abstractions using similar forms). For example, the sinuous drawing *Untitled (After*

the Ball Is Over) (fig. 5), published in *Vanity Fair* in November 1916, features bubbling patterns and a languorous figure that call to mind everything from an Aubrey Beardsley illustration to the opalescent whorls of Tiffany glass. In fact, one could argue that the forms and the subjects to which O'Keeffe repeatedly returned had more in common with ones used by artists of the Art Nouveau era than with those of her fellow modernists.

The abiding preoccupation with nature around the turn of the twentieth century – a phenomenon that Paul Greenhalgh identified as one of the key factors unifying artists identified with the Art Nouveau style worldwide – certainly resonated with O'Keeffe as well. The vast majority of her paintings, especially those incorporating circular forms, feature subjects from the natural world, eschewing the art community's growing fascination with the geometry of machines, skyscrapers, and other streamlined forms of early twenti- eth-century design that were quickly coming to represent modern life.[11]

Even before her breakthrough abstractions of 1915/16, O'Keeffe had long sought refuge in and drawn inspiration from nature. The places in which she lived as a child and that she sought out during most of her adult life (especially, after 1929, New Mexico), were decidedly rural.[12] Her early letters to her friend Anita Pollitzer are peppered with references to exhilarating or inspirational experi- ences in the natural world. During a particularly frustrating time in South Carolina, for example, she wrote that she wanted to take a long walk, that she could always "live in the woods," meaning, I believe, that she could come alive there rather than reside there. "Maybe," she continued, "I'll have something to say then."[13]

Indeed, nature was a primary inspiration for O'Keeffe's early abstractions. Her paint- ings and drawings depict the natural world in constant motion, a site of continual growth and change. Sweeping charcoals such as *Early No. 2* (plate 2), for example, seem to have emerged in part from studies of a group of trees on a hilltop, both also from 1915: *Untitled* (Amon Carter Museum, Fort Worth) and *Second, Out of My Head* (fig. 6).[14] The spiraling forms that enter O'Keeffe's work in this period also invoke a wide range of natural phenomena, from the coil of a fiddlehead fern to the eddies of a rushing brook. O'Keeffe herself commented that the vivid pastel *No. 32 – Special* (fig. 7) was a representation of her and a friend from Virginia, "dabbling our feet in the water ... [which is] red from the red clay – and comes down with a rush like all

Fig. 6 Georgia O'Keeffe, *Second, Out of My Head*, 1915
Charcoal on paper; National Gallery of Art, Washington, Alfred Stieglitz
Collection, Gift of The Georgia O'Keeffe Foundation

the mountain streams. He got me to put my feet in because he said the motion of the water had such a fine rhythm.... Those two things [*No. 32 – Special* and *Special No. 33* (1915; Private Collection, New York)] were just my ways of trying to express it to him."[15]

Although O'Keeffe was in New York only infrequently before 1918, she kept up with developments in the art world through books and periodicals. Along with Stieglitz's mouthpiece *Camera Work*, two publications that likely helped to shape and reinforce her emerging formal vocabulary were Wassily Kandinsky's *Concerning the Spiritual in Art* and Willard Huntington Wright's *Modern Painting: Its Tendency and Meaning*. Kandinsky's book was excerpted in *Camera Work* as early as 1912, its date of publication, which preceded by at least one year the English translation of the entire volume. O'Keeffe knew about the book soon after it had appeared in translation, and by 1915 reported to Pollitzer that she was reading it again and that "it was reading much better."[16] In general, Kandinsky's emphasis on the connection between the inner and the outer, that is, between the spirit, soul, and emotions of artists and the subjects that they chose to paint, and his belief that this relationship could be made visible in a work of art, must have been reassuring to O'Keeffe at the very moment when she was seeking new inspiration and direction.[17] Certainly, her charcoals and watercolors over the next few years, some of which she characterized as "somewhat like myself – like I was feeling," are among the most eloquent realizations of this idea ever produced.[18]

Kandinsky dissected visual art into two primary components: form and color. Of particular relevance here is his discussion of the psychological impact of rounded shapes. He wrote that "sharp colors are well suited to sharp forms (e.g., yellow in the triangle) and soft, deep colors to round forms (e.g., blue in the circle)."[19] While she did not always adhere to this dictum, O'Keeffe did frequently use blue with circular forms (see *Blue I* [1916; The Tobin Foundation]; *Blue II*; *Abstraction*; *Light Coming on the Plains No. III*; and predominantly in *Untitled (Red, Blue, Yellow)*; *Pink and Blue, No. 1* [1918; Collection of Barney A. Ebsworth]; and *Music - Pink and Blue II* (plates 4 – 8) as well as in her later paintings of pelvic bones (plates 33 – 38 and 42), in which blue and white dominate.

Kandinsky's ideas about the connections between art and music also would have held meaning for O'Keeffe, who had recently taken up the violin. Her correspondence from this period indicates an interest in translating into two-dimensional form feelings engendered by hearing music; to do so, she often used curving,

Fig. 7 Georgia O'Keeffe, *No. 32–Special*, 1915
Pastel on paper; Smithsonian American Art Museum, Washington,
Gift of The Georgia O'Keeffe Foundation

Fig. 8 Morgan Russell, *Cosmic Synchromy*, 1913 – 14
Oil on canvas; Munson-Williams-Proctor Arts Institute, Museum of Art, Utica, New York

arching shapes.[20] This line of inquiry seems to have inspired works as different visually as *No. 20 – From Music – Special* (plate 3), in which suggestions of musical notation fill the composition, and *Music – Pink and Blue II* (plate 8) a more abstract painting that suggests the soaring sensation and emotional timbre inspired by the experience of listening.[21]

The other book cited in O'Keeffe's letters to Pollitzer, Wright's *Modern Painting*, was, along with Arthur Jerome Eddy's *Cubists and Post Impressionists*, one of the most extensive analyses of the development of modern art then available.[22] Like Kandinsky, Wright sought to identify the qualities essential to what he believed was the very best art, particularly recent art. Key to him was "the organization of form … it is best organized to have a distinct rhythm…. The deeper and larger qualities in a painting … are not to be found in its documentary and technical side."[23] He concluded that the ideal work of art would be "wholly synthesized as to volume, color, line, direction, size and subject," or, more succinctly, that artists must strive for the "perfect concord of line, form, and subject."[24] O'Keeffe – and most artists – would certainly have agreed. Wright concluded that all of the hallmarks of "good" art could be found in the work of a new group to whom he was closely linked, and of whom O'Keeffe was certainly aware: the Synchromists, whose compositions frequently featured swirling, kaleido-scopic disks of color (fig. 8).

The Synchromists' goal was to translate light playing across the surfaces of objects into pure color. The two principal members of this group were Stanton MacDonald-Wright (Willard Huntington Wright's brother) and Morgan Russell. Although O'Keeffe was not in New York in March 1914, when Russell and Wright made their American debut at the Carroll Galleries, she would soon come to know them through Willard Wright's book and the *Forum Exhibition of Modern Art* in 1916 and its catalogue.[25] Perhaps most important, at least for O'Keeffe, was Stieglitz's endorsement of the group. He had purchased Russell's *Archaic Composition No. 1* (1915; The Museum of Modern Art, New York) from the Forum show, and the grateful artist gave him its companion, *Archaic Composition No. 2* (1915; The Museum of Modern Art, New York). In November – December 1916, O'Keeffe would have had the opportunity to see her own work exhibited alongside MacDonald-Wright's in a group show at Stieglitz's 291 gallery. She just missed MacDonald-Wright's solo exhibition at the gallery the next year, but did see his work again when she arrived in the city in 1917, for she wrote appreciatively to Pollitzer:

"He [Stieglitz] has a new Wright, and I saw another one. – both synchromist things that are wonderful – Theory plus feeling – They are really great."[26]

Although O'Keeffe and the Synchromists ultimately had different goals, means of achieving these goals, and sources of inspiration, they were united by their common interest in circular forms. Russell, for one, traced his fascination back to the work of other artists, saying that he had "always felt the need of imposing color on the violent twists and spirals that Rubens and Michelangelo etc. imposed on form."[27] But whereas the Synchromists' forms are most often fractured and segmented, O'Keeffe's tend to be undulating and organic. This distinction likely exists because the Synchromists generally took an objective, analytical, almost scientific approach to making a painting, while O'Keeffe's process, especially at this time, stemmed from a more intuitive and subjective interaction with her subject. For Russell and his followers, a subject might supply the starting point for the organization of color, but thereafter, color itself would dictate the forms, balance, and tension in the painting. He wrote in 1913: "One often hears painters say that they work on the forms first, in the hope of arriving at the color afterwards. It seems to me that the opposite procedure should be adopted."[28] For O'Keeffe, color served to enhance form, and the two worked together to emphasize a particular quality about the subject itself and its meaning to the artist. Nevertheless, her work shares with that of the Synchromists a similar dynamism and effort to break new artistic ground, generated, in part, through an inspired use of circular forms.

Finally, among the many sources impacting O'Keeffe's formal vocabulary in the 1910s was the wide range of art she came into contact with thanks to Stieglitz – whether through reading *Camera Work*, viewing exhibitions at 291, or, after 1918, joining Stieglitz and his friends in their lengthy discussions about contemporary art. *Camera Work*, for example, contained many images, such as George H. Seeley's *The Burning of Rome*; Maurice de Zayas's caricature *Mrs. Eugene Meyer, Jr.* (fig. 9); and even Frank Eugene's *Mr. Alfred Stieglitz*, that might have inspired O'Keeffe's *Early No. 2*, or even later paintings such as *Lake George, Coat and Red* (plates 2 and 10). Likewise, the hunched figures in images such as Frank Eugene's *La Cigale*, George H. Seeley's *The Pool*, or Edward Steichen's *Nude*

Fig. 9 Maurice de Zayas, *Mrs. Eugene Meyer, Jr.*, 1914
Photogravure; *Camera Work* 46, 39 (October 1914)

Fig. 10 Edward J. Steichen, *Nude with Cat*, 1903
Gum, halftone print; *Camera Work* 2, 39 (April 1903)

with Cat (fig. 10) also find echoes in the shapes of her early water-colors, such as *Blue II* (plate 4).

Stieglitz held approximately seventeen exhibitions of modern art at 291 during the periods O'Keeffe spent in New York between 1907 and 1918.[29] These ranged from photographs by Edward Steichen, Paul Strand, and himself to paintings and drawings by European modernists such as Henri Matisse, Auguste Rodin, Georges Braque, and Pablo Picasso, and Americans such as Marsden Hartley and John Marin. Although O'Keeffe was not in New York during the run of other important exhibitions that would likely have featured artists working with circular forms, such as Constantin Brancusi, Arthur Dove, and Stanton MacDonald-Wright, and the American debut of the Synchromists at Carroll Galleries, she was in town during the Forum Exhibition of Modern American Painters (coorganized by Stieglitz and conceived in response to the Armory Show) and for exhibitions of the work of Francis Picabia and Abraham Walkowitz, all of which included abstractions in this vein. And judging from her appetite for learning about the latest advances in modern art during this period, one can surmise that O'Keeffe would likely have known something about the shows that she missed.

Perhaps most astonishing is how distinct O'Keeffe's approach to abstraction – particularly her use of circular forms – was from that of her peers by 1918. Her paintings and drawings reveal a keen conceptual awareness of recent developments combined with a spare, elegant aesthetic and a deeply spiritual connection to the process of making art. From sweeping, spiraling arcs to pulsing ovoids and swirling coils of visual energy, such forms sometimes are the visual equivalent of a vortex pulling the viewer's eye toward their center or pushing it outward beyond the boundaries of the canvas. In other instances, elegant forms sweep upward into a concentrated knot. Although interest in abstraction increased in America following the Armory Show, O'Keeffe was not concerned with translating the forces of modern life into pictorial form, exploring the ramifications of the geometric structures suggested by Cubism, or attempting to fuse color and form like the Synchromists. Instead, she developed her forms as equivalents of her own feelings and her perceptions of the natural world, as she expressed metaphorically to Pollitzer during a period of excited inspiration: "The world just seems to be on wheels – going so fast I cant [*sic*] see the spokes – and I like it."[30]

NOTHING IS LESS REAL THAN REALISM. DETAILS ARE CONFUSING.
IT IS ONLY BY SELECTION, BY ELIMINATION, BY EMPHASIS THAT WE GET
TO THE REAL MEANING OF THINGS. GEORGIA O'KEEFFE, 1922[31]

In the summer of 1918, O'Keeffe moved in with Stieglitz, motivated in part by his enthusiastic and encouraging promotion of her work (and its resulting critical success) and in part by the opportunity to join an active, vibrant community of artists. O'Keeffe's gender and sheer originality led Stieglitz to create a stereotype of her and her work that was based as much on her as a woman as on the striking modernity of her paintings and drawings.[32] By the early 1920s, these gendered and sexually oriented interpretations of O'Keeffe's art had become widespread, augmented further by Stieglitz's own nude photographs of the artist. Strongly promoted by Stieglitz and his peers, these views also fed into the cultural perceptions of the period. Those writing about her work from 1917 well into the 1920s took this angle almost exclusively. Although O'Keeffe's earliest documented response to such interpretations did not appear until 1922, the still lifes that emerged between 1919 and 1923, mixed in among views of Lake George and her early flower abstractions, suggest that she was even then seeking to avoid this stigma through works approaching abstraction from a slightly different angle, primarily through photography and Paul Cézanne.[33]

From the moment of her arrival in New York, photography crept into virtually every aspect of O'Keeffe's life and, more subtly, her art.[34] Not only did she immediately become the subject of an extended "portrait" by Stieglitz, one of the medium's most important practitioners and advocates, but through him she learned its technical details. Even before the move to New York, *Camera Work* had helped O'Keeffe to appreciate photography as a true artistic medium as well as for its relevance to modern art; furthermore, Dow's counsel regarding filling a space in a beautiful way paralleled the manner in which photographers were taught to select and frame a composition.

Apart from Stieglitz, Paul Strand was certainly the photographer who had the most sudden and probably the strongest impact on O'Keeffe. In the highly innovative photographs he created during the summer of 1916, Strand experimented with compressed space, disorienting perspectives, and bold, simplified compositions dominated by a new sense of geometry; he appeared to be returning to the basics of picture-making and literally "rebuilding his art from within."[35] One famous subgroup of this series focuses on the curves and counter-curves of white bowls (fig. 11), and is therefore formally relevant for O'Keeffe's subsequent still lifes.

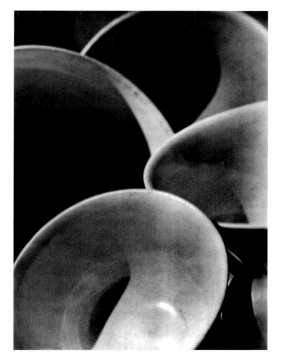

Fig. 11 Paul Strand, *Abstraction, Bowls, Twin Lakes, Connecticut*, 1916
Silver and platinum print; The Metropolitan Museum of Art, New York, Alfred Stieglitz Collection

The subjects – while still recognizable and carrying their traditional symbolism and "meaning" – have been forcibly abstracted to fit the artist's compositional needs, thereby becoming valuable for their form as well as content. As Strand himself realized: "The simplest of subject matter, or maybe object matter would be a better term in this case … [was] my material for making experiments to find out what an abstract photograph might be, and to understand what an abstract painting really was."[36] Peters has noted how this series confirmed for O'Keeffe what she had already learned from Dow about cropping, flatness, frontality, and balancing a composition with tonal values.[37] It is also likely that because of her close relationship with Strand, O'Keeffe knew not only the famous image of bowls, but also its less well-known variants and trial proofs, some of which also feature pieces of fruit.[38]

That Stieglitz thought very highly of Strand at this moment is apparent in his writings in *Camera Work*, where he celebrated Strand as a "man who has actually done something from within" [from within himself and probably from "within" the United States] and described his pictures as "being rooted in the best traditions of photography."[39] He included six photographs from this series in the final issue of the periodical, including a "bowl" image that he also owned (see fig.11). Stieglitz's comments about Strand echo closely his early praise of O'Keeffe, and it must have been very exciting for these two young protégés to meet one another in 1917.[40]

Although it was not long before O'Keeffe wrote to Strand to say that she had "been seeing things as he might photograph them," her work comes closest to his in both aesthetics and subject matter in a loose series of still lifes executed between 1919 and 1923.[41] Following a brief stint of military service, in 1919 Strand headed for Lake George to spend time with Stieglitz and O'Keeffe. His safe return home would have made his company particularly meaningful and it is surely more than a coincidence that his visit occurred just before O'Keeffe began work on her own still lifes.[42] Some of her paintings of apples during the fall of Strand's sojourn at Lake George are filled with dense groups of rounded forms. Soon, however, she began to simplify her compositions and her color schemes – like Strand, she seemed to be rebuilding her art from within, possibly in reaction to the growing commentary on her work that continually focused on gender and sexuality and ignored the compositional and structural innovations.[43]

Over a four-year period (1919–23), O'Keeffe maintained a preference for filling much of the pictorial space with roughly centralized forms – typically apples and avocados (sometimes called alligator pears) on plates or in baskets – a format that she had come to favor as early as 1915. Less abstract than the earlier work, these paintings nonetheless broke new ground in terms of the innovative and exploratory nature of their compositions and their contrasts and tensions. Both *Dark Red Apples & Tray No. 2* and *Green Apple on Black Plate* (plates 12 and 14), for example, feature radically skewed viewing angles, juxtaposing a compressed pictorial space created by the flat black disk of the plate and the simple white background, and the illusionistic fullness of the fruit. In pictures such as *Red Apple on Blue Plate* (plate 13), O'Keeffe also played with the visual tension created by the small distance between the edge of the plate and the edge of the canvas. She continued experimenting with these concepts in her subsequent paintings of avocados (plate 15). In one of the most abstracted examples of the group, *Alligator Pears in a Basket* (1921; National Museum of Women in the Arts, Washington) is even difficult to determine whether the dark ovals of fruit sit in a basket or on a plate.

This series allowed O'Keeffe to reconsider her approach to composition and pictorial relationships. The traditional subject matter, simplified forms, carefully constructed compositions, spatial compression, and tipped-up perspective call to mind not only Strand's photographs of 1916, but also the work of Cézanne, who by the 1910s had come to be known as one of the fathers of modernism.[44] Arthur Jerome Eddy described Cézanne as an artist "busy with the *substance* of things," who labored "to paint, to *learn how* to paint, *simpler* and *truer* interpretations [of his subjects]," and who "used the simplest and most direct technique, not a brush-stroke, not a line, not a spot of color wasted" – a description that could fit O'Keeffe equally as well, despite her terse dismissal of connections between their work.[45] Stieglitz had shown Cézanne watercolors in 1911 and illustrated three of his paintings (including one still life) in the June 1913 issue of *Camera Work*. O'Keeffe likely just missed a Cézanne exhibition in January 1916 at Montross Galleries, for which Willard Huntington Wright wrote a glowing review.[46] Stieglitz endorsed the view of Cézanne as a father of modern art by publishing in *Camera Work* writings by Charles Caffin, who, like his mentor Roger Fry, believed Cézanne's work to be a cornerstone of modernism.

While Eddy devotes just a few paragraphs to Cézanne, Wright, whose prose O'Keeffe found much more compelling, not only uses a Cézanne landscape as the frontispiece to *Modern Painting* (and also illustrates a still life of apples later in the book), but gives the artist an entire chapter. He consistently praises Cézanne's genius, describing his innovations and summarizing his theories, often using the artist's own words. There are similarities with O'Keeffe's own concerns. Her early self-imposed restraint to work

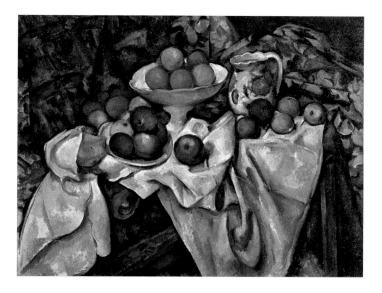

Fig. 12 Paul Cézanne, *Still Life with Apples and Oranges*, ca. 1895–1900
Oil on canvas; Musée d'Orsay, Paris

only in charcoal until she felt comfortable enough with the medium to return to painting, echoes Cézanne's dictum that one had to be the master "of one's means of expression."[47] And Cézanne's compositions, as described by Wright, have much the same coherence and self-sufficiency that would have been familiar to O'Keeffe through Dow's lessons. Wright also lauds Cézanne's skill at capturing the contrasting qualities of solidity and motion in the natural world, and meshing them together through a masterful unification of painting, drawing, and color. "In his best canvases there seems no way of veering a plane, of imagining one plane changing places with another, unless every plane in the picture is shifted simultaneously.... There is a complete ordonnance between every minute part, and between every group of parts. Nothing can be added or taken away without changing the entire structure in all its finest details."[48] Although O'Keeffe's still lifes are frequently less complex than Cézanne's, such a statement could easily be applied to them as well – a testament to how well she integrated an understanding of his work into her own artistic practice.

But while her compositions are certainly as self-reliant as those of Cézanne, O'Keeffe approached her subject matter very differently, subjecting it to intense scrutiny not to "master" it but rather to know it more intimately. There is little hesitation in how these subjects are recorded on her canvases – as Remington advised, she did her hardest work *outside* the picture, leaving little sense of the choices that she made while painting – everything simply feels that it is where it is supposed to be. There is often a complexity to Cézanne's still lifes that one does not find in O'Keeffe's images. Where O'Keeffe limited her subject matter to apples and avocados, plates and baskets, and floated them against a nondescript background, Cézanne often included tables and identifiable background spaces in his paintings of apples, oranges, bananas, vessels, statuary, and other compositional elements (fig. 12). One could argue, however, that through this reduction, O'Keeffe gave her subjects an iconic quality in contrast to Cézanne's investigation of objects in space. It is important to note that in addition to her still lifes, during these years O'Keeffe was simultaneously developing her magnified flowers, creating scenes of Lake George, and exploring new directions in abstraction. But as the 1920s wore on, she brought the new formal rigor of her still lifes to bear on both her landscapes and her paintings of shells, rocks, wood, and bones.

IT IS SURPRISING TO ME HOW MANY PEOPLE SEPARATE THE OBJECTIVE FROM THE ABSTRACT. OBJECTIVE PAINTING IS NOT GOOD PAINTING UNLESS IT IS GOOD IN THE ABSTRACT SENSE....

For me that is the very basis of painting. The abstraction is often the most definite form for the intangible thing in myself that I can only clarify in paint. Georgia O'Keeffe, 1976 [49]

Even if I could put down accurately certain things that I saw & enjoyed it would not give the observer the kind of feeling the object gave me. – I had to create an equivalent for what I felt about what I was looking at – not copy it. Georgia O'Keeffe, 1937 [50]

By the mid-1920s, O'Keeffe had moved away from the eddying vortices of her early abstraction and the reactionary staid formalism of her subsequent still lifes, returning with gusto to her intense scrutiny of the natural world. Except for a handful of paintings of New York City (executed mostly between 1925 and 1928), the vast majority of her oeuvre from this point onward records her fascination with sweeping views of the American landscape as well as its more discrete elements that she observed and collected throughout her life.

Her preoccupation with these subjects, especially between the 1920s and 1940s, is especially interesting because during this period an increasing number of avant-garde artists in America and abroad were moving in rather different directions. Their work ranges from precise, streamlined paintings that responded to the rapidly developing urban world to increasingly abstract, even nonrepresentational, canvases filled with stark geometric forms. Even artists associated with Stieglitz, such as Charles Demuth and Charles Sheeler, began painting the American industrial scene during these decades, inspired by the geometry and symbolism of its buildings and products (fig. 13). Unlike her early charcoals and watercolors, O'Keeffe's later depictions of the landscape – especially those of New Mexico following her first trip there in 1929 – rarely incorporate the pulsing circular forms found in her other subjects, though such motifs occasionally appear in her paintings of Lake George and New York City.

Between 1919 and 1929, most of O'Keeffe's landscapes were inspired by the scenery of Lake George, which she had first visited with Alfred Stieglitz in 1918.

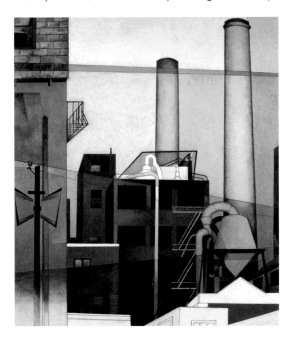

Fig. 13 Charles Demuth, *After All*, 1933
Oil on composition board; Norton Museum of Art, West Palm Beach, Bequest of R. H. Norton

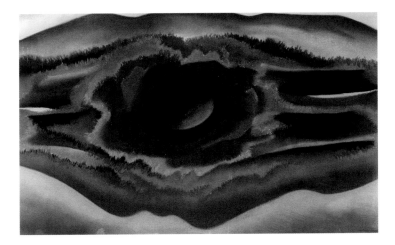

Fig. 14 Georgia O'Keeffe, *Pool in the Woods, Lake George*, 1922
Pastel on paper; Reynolda House Museum of American Art, Winston-Salem,
North Carolina; Gift of Barbara Millhouse in Memory of E. Carter,
Nancy Susan Reynolds, and Winfred Babcock

The lake's rounded banks and surrounding hills were well
suited to O'Keeffe's formal vocabulary. Among the most abstract
of these images is the large, richly worked pastel *Pool in the
Woods, Lake George* (fig. 14), in which a body of water (perhaps
the lake itself) has been reduced to a shimmering disk, tipped up
parallel to the picture plane, and set within concentric rings of brown earth and green foliage, framed by blue hills and sky. Working
in series, as she often did throughout her career, O'Keeffe honed in on the central form of this pastel in two subsequent works,
Pond in the Woods (plate 19) and *Lake George in Woods* (1922; Private Collection, San Francisco), shifting from the traditional
horizontal landscape to a vertical format, eliminating the horizon, and reducing the entire composition to a swirling mass of earth,
greenery, and sky, spiraling to a watery center. Numerous other Lake George landscapes picture the surrounding hills reflected
on the lake's glassy surface, often divided by a horizontal shoreline.

O'Keeffe's undulating, nature-oriented forms set her work apart from that of other American modernists, such as the Precisionists,
with whom she is occasionally grouped because of the clear, crisp linearity of many of her paintings. Even in the 1920s, when she
turned her attention to a favorite subject of the Precisionists, the skyscrapers of New York, her paintings do not seem intended to
celebrate technology and industry. Never quite as streamlined or sleek as those of her peers, these works maintain a distinct sense
of the organic residing within the city, never completely eliminating references to the natural world.

The city first appears in O'Keeffe's oeuvre in 1919 but the vast majority of her urban paintings date between 1925 and 1928. In these,
O'Keeffe frequently contrasted the rectilinear outlines of the city with soft, rounded forms emanating light. In *New York Street with
Moon* (1925; Carmen Thyssen-Bornemisza Collection, Lugano, Switzerland), for example, her first major oil of the city, the moon
floats in a bed of clouds above the glowing orb of a streetlight hovering over a pulsing spot of red below.[51] This treatment of the
urban scene reaches a crescendo with *The Shelton with Sunspots, N. Y.* (fig. 15), in which light has overwhelmed visible structure.
Blinding reflections off polished stone and metal surfaces transform the city into a pulsating mass of fiery yellow and orange
orbs and spots and literally eat into the upper stories of the Shelton Hotel. A quieter transformation takes place under the softer
light of the moon, as seen in *City Night* (plate 21), in which the buildings closing in toward the top of the composition threaten to
overwhelm the viewer. Relief is provided by the moon's cool reflections at the very bottom of the canvas, which offer a welcome
contrast to the darkness and linearity of the rest of the painting.[52]

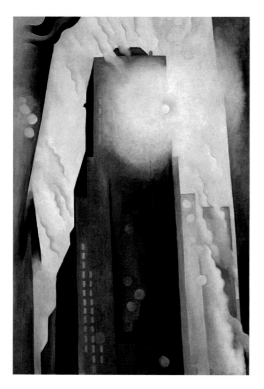

Fig. 15 Georgia O'Keeffe, *The Shelton with Sunspots, N. Y.*, 1926
Oil on canvas; The Art Institute of Chicago, Gift of Leigh B. Block

Not surprisingly, O'Keeffe's depictions of the city ended in 1929, the same year that she traveled to New Mexico, as if the power of the landscape that she encountered there made it impossible for her to return, at least in her art, to the man-made modernity of New York. For her, the ancient mesas and rounded adobe architecture of the West struck a chord and became timeless icons of what was "real" and "American." Rocks, bones, and pieces of wood became as worthy of her scrutiny as the terrain they occupied. Although the majority of her mature paintings maintain fairly close visual ties to their subjects, abstraction continued to spiral in and out of her artistic practice.

While most members of Stieglitz's circle devoted considerable energy to capturing the spirit of the American landscape, Arthur Dove's artistic sensibilities were most closely attuned to those of O'Keeffe.[53] He, too, incorporated circular forms into his compositions throughout his career, but in different ways and for different purposes. Unlike O'Keeffe, Dove almost always used such forms to represent the sun or the moon (fig. 16), although occasionally they serve as the canopy of a tree, a bulbous gas tank, or even as a visual equivalent of the low swelling sound of a fog horn. But for the most part, Dove used these forms to represent the power of light, and incorporated them into coherent landscapes rather than isolating them as, or locating them within, discrete objects – O'Keeffe's typical strategy. Like light itself, Dove's suns and moons become diffuse as they radiate outward, a natural phenomenon despite their abstraction, while his paintings themselves operate within the traditional landscape formula with horizontal registers and a horizon line. Nonetheless, despite their different applications of this form, Dove and O'Keeffe both created works that flirt with abstraction but almost always maintain close enough ties to their sources as to remain legible.

O'Keeffe's approach to abstraction also differed vastly from the practice of her peers outside of the Stieglitz circle and outside of the United States. By the 1930s, many European models existed abroad and were increasingly visible in American museums and galleries. The Armory Show of 1913 is generally credited with introducing Cubist abstraction to America. Its effect on American art was wide-ranging and long-lasting. As Bruce Weber has recently noted, American artists who incorporated Cubism into their work

in the 1920s and 1930s took a risk, for these years saw a "resurgence of conservative nationalism in American art."[54] The most vocal advocate of a "pure" American art, free of influence from overseas, was Thomas Craven, who set forth his reactionary opinions in the chapter summaries of his 1934 book *Modern Art: The Men, The Movements, The Meaning*. While Matisse and Picasso are vilified (the former for his "boudoir patterns devoid of human meanings" and the latter as "a compositor interested only in manipulating the forms of other painters"), Craven reserves his highest praise for Thomas Hart Benton, lauding him for his "original style, "powers of design," and for seeing "himself [first] as an American, then as an artist."[55]

Despite Stieglitz's ardent support for American art and artists, Craven denigrates him as a kind of hypnotist, who used his "psychological gift" to influence "not only "naïve susceptibilities" but also "minds trained in the critical process of thinking." Craven concludes that "it is a matter of record that none of the artists whose names and work he has exploited has been noticeably American in flavor." He allows, however, that O'Keeffe – one of the few American modernists who had not been to Europe – has talent and even a "touch of genius."[56]

In the face of European abstraction, various groups of American artists began to coalesce, both unofficially and officially, rejoining the decades-long battle to show the world that the United States was as capable as any country of producing ground-breaking art. Loose-knit groups, such as the circle of friends centered around Stuart Davis, Arshile Gorky, and John Graham (who were later dubbed the "Three Musketeers" by Willem de Kooning) and the web of students who had worked with Hans Hofmann, as well as more official ones, such as "The Ten," which included Adolph Gottlieb and Mark Rothko, had begun to form a critical mass of practitioners of abstraction by the mid-1930s. In late 1936, the American Abstract Artists group was officially established, becoming by far the most cogently organized and longest-lived of the bunch. Its existence was prompted by The Museum of Modern Art Director

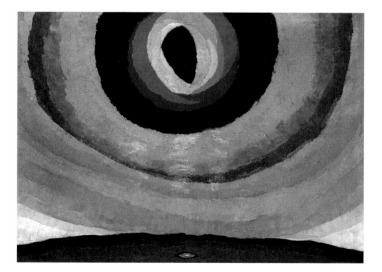

Alfred Barr's exclusion of American artists from his important exhibition that year, *Cubism and Abstract Art*, as well as by the Whitney Museum's 1935 exhibition of American abstract art that was seen as not recognizing enough "contemporary" artists.[57]

While O'Keeffe might have shared the American Abstract Artists' "repudiation of anecdotal or specific social reference" in her work, there is no indication that she sought to create forms that spoke to

Fig. 16 Arthur Dove, *Silver Sun*, 1929
Oil and metallic paint on canvas; The Art Institute of Chicago,
Alfred Stieglitz Collection

or symbolized contemporary American culture.[58] By this point, she simply was painting what interested her in her own mature style, neither attempting to revolutionize her medium nor to push for an "American" art or a specific message of social change. By the 1930s, painting for O'Keefffe had become a highly personal exercise rather than a bold statement of independence. One of the few exceptions to this – and perhaps the closest that O'Keeffe ever came to specifically trying to create an iconic "American" painting – is *Cow's Skull: Red, White and Blue* (fig. 17). O'Keeffe later wrote that "As I was working I thought of the city men I had been seeing in the East. They talked so often of writing the Great American Novel – the Great American Play – the Great American Poetry.... So as I painted along on my cow's skull on the blue I thought to myself, 'I'll make it an American painting. They will not think it great with the red stripes down the sides – Red, White, and Blue – but they will notice it.'"[59]

By the end of the 1920s, most American critics had come to accept the semi-abstract work of the Stieglitz circle, but a good number were still not yet ready to praise the latest developments in abstraction from overseas, let alone those on this side of the Atlantic. Lewis Mumford's comments about the Pierre Matisse Gallery's 1932 Miró show (and, simultaneously, the work of Mondrian) reflect the conservative American response: "In the case of both Miró and Mondrian, I am not ready to say, with the little boy in Hans Andersen's fairy tale, that the Emperor has no clothes. I would merely remark, with an eye to the grey November sky, that the Emperor must be rather cold."[60] This assessment corresponds with one of Craven's major criticisms of recent abstraction in America: that such work was so far removed from its original subject matter (if there had been any to begin with) that it was all form and no content. Five years earlier, a much more positive Mumford had called O'Keeffe "perhaps

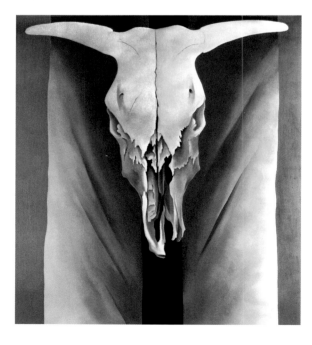

the most original painter in American today," and a producer of "pictures upon whose excellence one might well linger for a while." He even compared the development of her oeuvre to the blossoming of a plant that was continually producing "new shoots and efflorescences, now through the medium of apples, pears, egg-plants, now through leaves and stalks, now in high buildings and sky-scapes, *all intensified by abstraction* into symbols of quite different significance."[61] Abstraction as a tool for transformation and intensification was apparently acceptable to American critics but when its connections to the world of everyday things were less clear,

Fig. 17 Georgia O'Keeffe, *Cow's Skull: Red, White and Blue*, 1931
Oil on canvas; The Metropolitan Museum of Art, New York, Alfred Stieglitz Collection

its value and use came into question. As Mumford put it, O'Keeffe did not use abstraction to "hide an inner barrenness," but rather to enhance and enrich her means of communication.

While debates about "American-ness" and "subjectless" abstraction raged in the New York art world, O'Keeffe was spending less and less time there, even though her paintings were often included in group exhibitions that sought to define and classify various strains of abstraction as they emerged.[62] She remained allied to the Stieglitz circle, seemingly unmoved by the polemics of other groups of artists. She maintained an interest in abstraction, but never felt the need to shift toward completely nonrepresentational art. Interested more in her subjects than in the act of painting or composing itself, she seems to have sided with Kandinsky in avoiding what he cites as one of two "dangers" of abstraction: "the completely abstract use of color in geometrical form (danger of degenerating into purely external ornamentalism): pure patterning."[63]

It is informative to note which pictures O'Keeffe considered "abstractions." Four similarly sized flower paintings from her 1928 exhibition at Stieglitz's "Intimate Gallery," each of approximately the same year, indicate her thought process. Paintings numbered 16 and 17, *White Rose with Larkspur No. 1* (1927; Private Collection) and *White Rose with Larkspur No. 2* (1927; Museum of Fine Arts, Boston) both reveal the edges of the rose and other objects beyond; the form of the flower does not fill the entire composition. Number 19, however, *White Rose – Abstraction with Pink* (1927; Private Collection, San Antonio), permits only the slightest trace of anything beyond the form of the rose; the inclusion of the terms "abstraction" and "pink" in the title suggest the shift of focus. Finally, in number 41, *Abstraction White Rose* (plate 22), a composition filled entirely with swirling whites and grays, "abstraction" has come fully to the fore, as emphasized even by the primary placement of the word in the title of the painting.

For O'Keeffe, abstraction was a useful tool to help simplify and clarify her perception of the world: for her, the spiraling heart of the flower was in many ways its "truest" aspect. This was the case whether she was examining a city skyline or a cross-section of a tree. Rather than a means of ordering human experience on an existential level, O'Keeffe's "system" of abstraction was a way to amplify and intensify her experience through a more direct connection to her surroundings. While her paintings share the qualities of simplification, clarity, and a certain clean linearity with the work of her American peers experimenting with abstraction, her subjects remain securely rooted in the natural world.

I WAS THE SORT OF CHILD THAT ATE AROUND...THE HOLE IN THE DOUGHNUT, SAVING...THE HOLE FOR THE LAST AND BEST.

So probably – not having changed much – when I started painting the pelvis bones I was most interested in the holes in the bones – what I saw through them – particularly the blue from holding them up in the sun against the sky ... I have tried to paint the bone and the blue. Georgia O'Keeffe, 1943[64]

In 1943, when this statement appeared in the catalogue for her 1944 exhibition at An American Place, O'Keeffe had just begun painting the pelvic bones that she found during her long walks in the desert. The subject inspired one of her longest "series" devoted to a single object, stretching from 1942 into the 1950s. Originally, O'Keeffe seems to have responded to the bones' rugged beauty and potent symbolism; she portrayed them as self-contained, solid entities that efficiently communicate both the harshness of the desert and the timelessness of life itself. Her earlier cow skulls always floated alone or with flowers against a backdrop of desert or indeterminate pure color. With the pelvic bones, however, O'Keeffe slowly shifted her emphasis from the solid forms to the haunting voids that they framed. As she narrowed her focus over time, she brought the socket closer and closer to her eye, allowing the negative space rather than the unified whole to become the most important feature. Drawing meaning from emptiness or absence rather than fullness or presence was certainly a new concept for O'Keeffe, and perhaps explains her extended experimentation with the idea that a subject might be best captured by what it revealed and what it was *not* – by the space that it defined rather than the space that it occupied.

The series, which developed over six or seven years, reflects O'Keeffe's career-long artistic process: early works contain a fair amount of detail in both the description of the bone and its setting. She progressively smoothed and eliminated the irregularities and specificities, until by the final canvas in the series (plate 42), the ovoid opening is perfectly smooth, the bone almost stark white, and the sky beyond a cool blue that whitens as it reaches its innermost point. In the early iterations, the pelvic bones float ghostlike above the desert landscape, but O'Keeffe soon pulled the bones closer and closer, limiting her field of vision. The socket becomes a lens through which to view the world – a possible reference to the camera and to Stieglitz, who was terminally ill by the mid-1940s. Indeed, one of the most powerful pieces in the series, *Pelvis Series, Red with Yellow* (plate 39), might be interpreted not only as a meditation on the recent detonation of the atomic bomb but on Stieglitz's illness as well. This bone-as-lens was a startling departure from O'Keeffe's earlier use of skulls but shares with them and the artist's other abstractions involving circular forms a clear, centralized focal point (here, a void rather than a solid).

Daniel Catton Rich, one of the first to write about this series, noted that by zooming in toward the socket, O'Keeffe seamlessly merged the specific and the eternal, the micro and the macro, "into a luminous affirmation ... once again transformation has triumphed over observation."[65] This transformation – of a subject from the everyday world into a more iconic or timeless symbol – is also evident in one of the few sculptures created by O'Keeffe, titled simply *Abstraction*. Although *Abstraction* was conceived in 1946, the year of Stieglitz's death, the artist did not cast it until 1979/80, when she chose to execute it in three sizes: 10, 36, and 118 inches high (plates 40 and 41).[66] Although, as we have seen, O'Keeffe experimented with a wide range of circular forms of abstraction between 1915 and 1946, this sculpture seems to take inspiration as much from her early whirlpool forms (see plates 1, 2 and 4) as from the voids of her later pelvis paintings. Its spiraling form, sometimes thought to have been inspired by the curling tendrils of jimson weed, connects three decades of O'Keeffe's artistic innovation, pulling viewers' eyes hypnotically toward its center and encouraging them to look both *through* and *at* it simultaneously.

O'Keeffe continued to develop innovative ways to see the world in the 1950s and 1960s, most notably in her "patio door" series and her numerous paintings inspired by the experience of flying. *Green, Yellow and Orange* (plate 44) is a striking example of O'Keeffe's translation of the topographical features of an arid landscape. A dark, meandering line divides the composition diagonally, splitting at the bottom, and looping back to almost rejoin itself before taking a sharp turn and exiting the picture. Here O'Keeffe was likely depicting the winding course of a river, although photographs of the artist's studio reveal other, similar paintings that in fact depict tree branches. The radically tipped-up perspective – a result of recording the scene while in flight – makes the painting one of the most abstract of her entire oeuvre.

Other late paintings seem to indicate that the aging artist was becoming increasingly introspective, particularly as her eyesight failed her. After a decade-long hiatus from the subject, she returned to the format of her pelvis paintings in *Pedernal – From the Ranch I* (plate 43) and *Pedernal – From the Ranch II* (1956; Private Collection). Likewise, the shifting perspective and treatment of a body of water in *Mountains and Lake* (plate 45) recall the three paintings of Lake George from 1922, such as *Pond in the Woods* (plate 19). Even more obvious references to her early work occur toward the close of her career. For example, the charcoal *Untitled (Abstraction)* and watercolor *Untitled (Abstraction Orange and Red Wave)* of the 1970s (plates 49 and 50) echo not only the forms but also the media of *Early No. 2* and *Blue II* from 1915 and 1916 (plates 2 and 4). Such occurrences should be interpreted not as indications of a lack of creativity or thoughtless self-repetition, but rather as acts of highly personal self-reflection. Never exhibited during the artist's lifetime, these late works may have been a way for O'Keeffe to revisit the spontaneous forms that had been milestones at the beginning of her career. Literally and metaphorically, O'Keeffe had come full circle.

1 Frederic Remington, cited in Edwin Wildman, "Frederic Remington, the Man," *Outing* 46, 6 (March 1903), pp. 715–16; cited in William C. Sharpe, "What's Out There: Frederic Remington's Art of Darkness," in Nancy K. Anderson et al., *Frederic Remington: The Color of Night* (Washington: National Gallery of Art, 2003), p.18.

2 As Michael Auping has noted, abstraction is "an unwieldy and imprecise designation" that "pivots in a number of directions and accommodates various types and degrees." Among the kinds of abstraction that Auping describes is one "from nature, distilling the natural world's essential elements," a description that will suffice for how the term is used throughout this essay, as opposed to "a more radical form … which exists in what is often referred to as 'nonobjective' painting, in which forms, shapes, and colors do not relate to nature but exist rather on their own as pure invention." See Michael Auping, *Abstraction, Geometry, Painting* (New York: Harry N. Abrams, 1989), p. 18.

3 For a concise and thought-provoking synopsis of O'Keeffe's "modernity," see Barbara Rose, "O'Keeffe's Originality," in Peter Hassrick et al., *The Georgia O'Keeffe Museum* (New York: Harry N. Abrams, 1997), pp. 99–112.

4 Although O'Keeffe's use of abstraction has been discussed by a variety of authors (for example, see Charles Eldredge, *Georgia O'Keeffe* [New York: Harry N. Abrams, 1991], pp. 19–36), the most extended study of this particular motif in her art is Sharon R. Udall, "O'Keeffe and Texas," in Sharon R. Udall et al., *O'Keeffe and Texas* (San Antonio: The Marion Koogler McNay Art Museum, 1998), pp. 74–78.

5 In *Georgia O'Keeffe: A Studio Book* (New York: Abbeville Press, 1976), facing pl. 88.

6 See Elizabeth Turner, "The Real Meaning of Things," and Marjorie Balge-Crozier, "Still Life Redefined," in *Georgia O'Keeffe: The Poetry of Things* (Washington: The Phillips Collection, 1999).

7 O'Keeffe first encountered Dow's lessons in 1912 while taking classes from his follower Alon Bement at the University of Virginia. She worked with Dow himself two years later in New York. One of the best general studies of O'Keeffe's early development and influences is Sarah Whitaker Peters, *Becoming O'Keeffe: The Early Years* (New York: Abbeville Press, 1991).

8 See Katherine Kuh, interview with O'Keeffe, in Katherine Kuh, *The Artist's Voice: Talks with Seventeen Modern Artists* (Cambridge, Massachusetts: Da Capo Press, 2000), originally published as *The Artist's Voice: Talks with Seventeen Artists* (New York: Harper & Row, 1962)], pp. 189–203.

9 Peters, p. 190.

10 For O'Keeffe's exposure to Art Nouveau during these years, see ibid., pp. 41–61.

11 See Paul Greenhalgh, "The Cult of Nature," in *Art Nouveau 1890–1914* (London: V & A Publications, Inc., 2000), p. 55. In her choice of subject matter, O'Keeffe is most closely linked to her Stieglitz circle "naturalist" peers Arthur Dove (who did, however, occasionally paint organicized machines and vehicles), Marsden Hartley, and John Marin, and perhaps to tangentially related modernists of the era, such as Alfred Maurer.

12 Although she appears to have been inspired and energized by city life as well, this is probably due more to the people that she interacted with and the modern art that she could see rather than to the urban environment itself. Recent chronologies indicate that before settling in New York in June 1918, O'Keeffe was in the city from September 1907 to June 1908; September 1914 to September 1915; March–June 1916, and May–June 1917.

13 See O'Keeffe to Pollitzer, September 1915, in Clive Giboire, ed., *Lovingly, Georgia: The Complete Correspondence of Georgia O'Keeffe & Anita Pollitzer* (New York: Tenth Avenue Editions [for Simon & Schuster], 1990), pp. 32–33.

14 As Peters noted, O'Keeffe may have used the tree as an anthropomorphic symbol, and her library contained an early book about trees. See Peters, pp. 89–90 and Ruth E. Fine, Elizabeth Glassman, Juan Hamilton, and Sarah L. Burt, *The Book Room: Georgia O'Keeffe's Library in Abiquiu* (Abiquiu, New Mexico: The Georgia O'Keeffe Foundation; and New York: The Grolier Club, 1997), p. 42.

15 O'Keeffe to Pollitzer, October 1915, in Giboire, p. 48.

16 O'Keeffe to Pollitzer, September 1915, in ibid., p. 24.

17 See Wassily Kandinsky, *Concerning the Spiritual in Art* (New York: George Wittenborn, 1947), p. 23, n. 1: "A work of art consists of two elements: the inner and the outer. The inner is the emotion in the soul of the artist; this emotion has the capacity to evoke a similar emotion in the observer. Being connected with the body, the soul is affected through the medium of the senses – the felt. Emotions are aroused and stirred by what is sensed. Thus the sensed is the bridge, i.e., the physical relation, between the immaterial … and the material, which results in the production of a work of art." Gail Levin notes that O'Keeffe, who usually declined to discuss such things, emphasized Kandinsky's importance to her. See Gail Levin, "Kandinsky and the First American Avant-Garde," in Gail Levin and Marianne Lorenz, *Theme and Improvisation: Kandinsky & the American Avant-Garde, 1912–50* (Dayton: Dayton Art Institute; and Boston: Little, Brown, and Company, 1993), pp. 25–26.

18 O'Keeffe to Pollitzer, October 1915, in Giboire, p. 66.

19 Kandinsky, p. 47 (my emphasis).

20 See O'Keeffe to Pollitzer, October 1915, in Giboire, p. 71, for example.

21 Barbara Buhler Lynes has also suggested that the form of the Natural Bridge, which O'Keeffe had recently visited during her time in Virginia, may in

part have inspired the composition of *Music – Pink and Blue II* and the related works *Pink and Blue No. 1* and *Over Blue*.

22 Although O'Keeffe owned both books, she later confided that she found Eddy's most interesting for its pictures, which did include "circular" abstractions by Dove and Kandinsky, whereas she reported to Pollitzer in August 1916 that she had bought Wright's book for herself, and was going to read it "again." See Georgia O'Keeffe, *Georgia O'Keeffe* (New York: Penguin Books, 1976), opp. pl. 12; and O'Keeffe to Pollitzer, August 1916, in Giboire, p. 174.

23 Wright, pp. 19 – 20.

24 Ibid., p. 265.

25 Her library contains two copies, one uncut (perhaps Stieglitz's copy), and one inscribed by her in 1917.

26 See O'Keeffe to Pollitzer, June 20, 1917, in Giboire, pp. 255 – 56. Stieglitz's painting was likely *Synchromy* (1917; The Museum of Modern Art, New York). Stieglitz eventually owned at least two other MacDonald-Wrights, *Spring Synchromy* (1918; Fisk University, Nashville) and *Aeroplane: Synchromy in Yellow-Orange* (1920; The Metropolitan Museum of Art, New York).

27 Russell, cited in Gail Levin, *Synchromism and American Color Abstraction 1910 – 1925* (New York: George Braziller and the Whitney Museum of American Art, 1978), p. 23.

28 Ibid.

29 See the chronology of Stieglitz's exhibitions in Sarah Greenhough et al.., *Modern Art and America: Alfred Stieglitz and His New York Galleries* (Washington: National Gallery of Art; and Boston: Bulfinch Press, 2000), pp. 543 – 53.

30 O'Keeffe to Pollitzer, February 1916, in Giboire, p. 138.

31 "I Can't Sing, So I Paint! Says Ultra Realistic Artist; Art Is Not Photography – It Is Expression of Inner Life!: Miss O'Keeffe Explains Subjective Aspect of Her Work," *New York Sun*, December 5, 1922, p. 22, quoted in Barbara Buhler Lynes, *O'Keeffe, Stieglitz and the Critics, 1916 – 1929* (Ann Arbor: University of Michigan Press, 1989), p. 180.

32 Stieglitz formed his view very early on. In March 1918, in a letter to O'Keeffe just before she moved to New York, he described her as "The great Child pouring out some more of her Woman self on paper – purely – truly – unspoiled." Cited in Lynes, *O'Keeffe, Stieglitz*, p. 7. Lynes's book remains the most complete analysis of how critics perceived O'Keeffe and her work during her early career, and how she dealt with the expectations that resulted from such writings.

33 She wrote to a friend in 1922 that "Rosenfeld's articles have embarrassed me – [and] I wanted to lose the one for the Hartley book when I had t≠≠≠≠he

only copy of it to read.… The things they write sound so strange and far removed from what I feel of myself." She continued that she was "in a fury" when she read Rosenfeld's article, and was also upset by another article in *Vanity Fair*, in which the only thing that she liked was the line "Women Painters of America Whose Work Exhibits Distinctiveness of Style and Marked Individuality." See Lynes, *O'Keeffe, Stieglitz*, p. 58.

34 For the impact of photography on O'Keeffe's work, see Barbara Buhler Lynes in *Georgia O'Keeffe and New Mexico: A Sense of Place* (Princeton: Princeton University Press, 2004), pp. 51 – 56; Peters, pp. 183 – 221; and Lisa Messinger, "Sources for O'Keeffe's Imagery," in Christopher Merrill, ed., *From the Faraway Nearby: Georgia O'Keeffe as Icon* (Reading, Massachusetts: Addison-Wesley Publishing Company, 1992), pp. 55 – 64.

35 See Maria Morris Hambourg, *Paul Strand: Circa 1916* (New York: The Metropolitan Museum of Art, 1998), p. 34.

36 See Calvin Tomkins, *Paul Strand: Sixty Years of Photography* (New York: Aperture, 1976), p. 144.

37 Peters, pp. 192 – 93.

38 For images of these, see Hambourg, p. 33.

39 See Alfred Stieglitz, "Photographs by Paul Strand," *Camera Work* 48 (October 1916), pp. 11 – 12; and Alfred Stieglitz, "Our Illustrations," *Camera Work* 49 – 50 (June 1917), p. 36.

40 Stieglitz to O'Keeffe, March 31, 1918, in Anita Pollitzer, *A Woman on Paper: Georgia O'Keeffe* (New York: Simon & Schuster, 1988), p. 159. In fact, O'Keeffe's letter suggests that she initially fell for the young photographer but that their relationship soon became friendly and professional rather than romantic. For more on Strand and O'Keeffe, see Sarah Greenough, "Paul Strand, 1916: Applied Intelligence," in Sarah Greenough, ed., *Modern Art and America: Alfred Stieglitz and His New York Galleries* (Washington: National Gallery of Art; and Boston: Bulfinch Press, 2000), pp. 247 – 56.

41 See Georgia O'Keeffe to Paul Strand, on a train from New York to Texas, June 3, 1917, cited in Jack Cowart, Sarah Greenough, and Juan Hamilton, *Georgia O'Keeffe: Art and Letters* (Washington: National Gallery of Art, 1987), p. 161.

42 Strand went to Lake George almost immediately after being discharged from the Army. See Alfred Stieglitz to Arthur Dove, September 18, 1919, in Ann Lee Morgan, *Dear Stieglitz, Dear Dove* (Newark: University of Delaware Press, 1988), p. 66.

43 Hambourg, p. 34. It should also be noted that O'Keeffe was likely aware of the loaded nature of her subject matter in these still lifes, which symbolize everything from fertility to America to original sin. See Charles Eldredge,

Georgia O'Keeffe: American and Modern (New Haven and London: Yale University Press, 1993), pp. 180–87.

44 See Hambourg, esp. pp. 31–33; Jill Kyle, "Paul Cézanne, 1911: Nature Reconstructed," in Greenough, *Modern Art and America*, pp. 101–13; and John Rewald, *Cézanne in America: Dealers, Collectors, Artists, and Critics, 1891–1921* (Princeton: Princeton University Press, 1989).

45 See Arthur Jerome Eddy, *Cubists and Post Impressionists*, 2nd ed. (Chicago: McClurg and Company, 1919), pp. 35–37. O'Keeffe wrote in 1976 that her work "had nothing to do with Cézanne or anyone else." See O'Keeffe, *Georgia O'Keeffe*, opp. pl. 31.

46 See Rewald, pp. 288–301.

47 Cézanne, cited in Wright, pp. 137–38.

48 Ibid., p. 145.

49 O'Keeffe, *Georgia O'Keeffe*, opp. pl. 81.

50 Georgia O'Keeffe to an unidentified recipient, March 21, 193, cited in Eldredge, *Georgia O'Keeffe: American and Modern*, p. 171.

51 While Marsden Hartley states that O'Keeffe's frequent use of red tied her to a feminine artistic tradition (see Marsden Hartley, *Adventures in the Arts: Informal Chapters on Painters, Vaudeville, and Poets* [New York: Boni and Liveright, 1921], cited in Lynes, *O'Keeffe, Stieglitz*, p. 52), she also used the color to symbolize Stieglitz (see plates 9 and 10; and *Radiator Bldg – Night, New York* [1927; Carl Van Vechten Gallery of Fine Arts, Fisk University, Nashville], in which his name flashes on a red neon sign).

52 Karen Tsujimoto suggests that unlike the other Precisionists, O'Keeffe, along with Stefan Hirsch and George Copeland Ault, hesitated to celebrate the city because they were deeply ambivalent about it. Tsujimoto, for example, interprets the moon in *City Night* as being "crushed." See Karen Tsujimoto, *Images of America: Precisionist Painting and Modern Photography* (San Francisco: San Francisco Museum of Modern Art, 1982).

53 Paul Rosenfeld was one of the first to write about parallels between the two artists' work, linking them both to the earth, but he finds in them distinct differences related to their sex. See Paul Rosenfeld, *Port of New York: Essays on Fourteen American Moderns* (New York: Harcourt, Brace and Company, 1924), pp. 170–71. For a more recent analysis of the relationship between O'Keeffe and Dove and the way their work was contextualized during their lives, see Marcia Brennan, *Painting Gender, Constructing Theory: The Alfred Stieglitz Circle and American Formalist Aesthetics* (Cambridge and London: The MIT Press, 2001).

54 See Bruce Weber, *Toward a New American Cubism* (New York: Berry-Hill Galleries, 2006), p. 9.

55 See Thomas Craven, *Modern Art: The Men, The Movements, The Meaning* (New York: Simon & Schuster, 1934), pp. vii–xi.

56 Ibid., p. 312.

57 For more on this period, see Judy Collischan Van Wagner et al., *American Abstract Artists* (Bronx, New York: The Bronx Museum of the Arts; and Brookville, New York: Hillwood Art Gallery, 1986); Virginia Mecklenburg, *The Patricia and Phillip Frost Collection: American Abstraction 1930–1945* (Washington: Smithsonian Institution Press, 1989); John R. Lane and Susan C. Larsen, eds., *Abstract Painting and Sculpture in America 1927–1944* (Pittsburgh: Carnegie Institute; and New York: The Museum of Modern Art and Harry N. Abrams, 1983); and Weber, *Toward a New American Cubism*.

58 See John Elderfield, "The Paris–New York Axis: Geometric Abstract Painting in the Thirties," in John Elderfield, *Geometric Abstraction: 1926–1942* (Dallas: Dallas Museum of Fine Arts, 1972), section 7.

59 O'Keeffe, *Georgia O'Keeffe*, 1976, opp. pl. 58.

60 Mumford's review appeared in *The New Yorker*, November 19, 1932. This quotation is cited in William M. Griswold et al., *Pierre Matisse and His Artists* (New York: Pierpont Morgan Library, 2002), p. 158.

61 See Lewis Mumford, "O'Keefe [sic] and Matisse," *New Republic* 50 [March 2, 1927], pp. 41–42, cited in Lynes, *O'Keeffe, Stieglitz*, p. 264 (my emphasis).

62 For example, the Whitney Museum of American Art's *Abstract Painting and Sculpture in America*, 1935; The Museum of Modern Art's *Romantic Painting in America*, 1943; the circulating exhibition *Abstract and Surrealist Art in the United States*, 1944; the Brooklyn Museum's *Revolution and Tradition: an Exhibition of the Chief Movements in American Painting to the Present*, 1951; The Museum of Modern Art's *Abstract Painting and Sculpture in America*, 1951; and the Walker Art Center's *Reality and Fantasy: 1900–1954*, 1954.

63 Kandinsky, p. 72.

64 Georgia O'Keeffe, "I have tried to paint the Bone and the Blue," *Georgia O'Keeffe: Paintings – 1943* (New York: An American Place, 1944), reprinted in Barbara Buhler Lynes, *Georgia O'Keeffe: Catalogue Raisonné*, 2 vols. (New Haven and London: Yale University Press, 1999), vol. 2, p. 1099.

65 See Rich in Eldredge, *Georgia O'Keeffe: American and Modern*, p. 205.

66 When Stieglitz died, O'Keeffe was charged with the distribution of his estate, which contained a number of her early works. One might speculate that this forced encounter with her artistic past may, consciously or not, have inspired her to return to such forms in the present piece.

GEORGIA O'KEEFFE: IDENTITY AND PLACE BARBARA BUHLER LYNES

Georgia O'Keeffe's permanent move to northern New Mexico in 1949 could be interpreted as a demonstration of her rejection of New York, where her career was born and prospered, largely through the efforts of her dealer-husband Alfred Stieglitz. She lived and worked either in or near the city almost without interruption from 1918 until the end of the 1920s. But by that time, she had come to realize that her environment neither provided what she needed to continue to develop her work nor suited her temperament.[1]

Late in 1928, she had determined to spend the summer of 1929 elsewhere, debating between Europe, which she had never seen, and the Southwest, where she had lived and worked in the 1910s.[2] Opting for the latter, she traveled to northern New Mexico, which she had been immediately attracted to when she visited there briefly in 1917.[3] There, she again found a natural world for which she felt a strong affinity and to which she returned part of almost every year until making it her permanent home.

In moving to New Mexico three years after Stieglitz's death, did O'Keeffe reject New York? This could be a reasonable interpretation. She *did* retreat from the epicenter of the American art community to live in a then extremely remote and isolated area, a move that could have threatened her visibility and categorized her as a regionalist, thus undermining the position she had enjoyed for decades: that of one of America's leading and best-known modernists.

In what follows, I will argue that although O'Keeffe physically left New York in 1949, she hardly abandoned its art community. Rather, until her death in 1986, she maintained strong ties with New York, and she and her work remained vital, dynamic forces within it. Moreover, had she not moved to New Mexico, she might not have fully realized a goal she had initiated in New York in the early 1920s. Indeed, being away from the city made it possible for her to define herself to the American public in her own way and on her own terms and to craft a public persona that not only countered, but also ultimately replaced, the one Stieglitz, as impresario of her career, had established of her beginning in the 1910s.

By the time O'Keeffe met Stieglitz in 1916, he was a celebrated photographer and one of this country's most vocal champions of modern art.[4] Furthermore, he was then unusual in his belief that women could achieve greatness as artists; by the mid-1910s, he had long been in search of someone to fulfill that prophecy.[5] In January 1916, when he first saw a group of O'Keeffe's drawings, including her *No. 4 Special* (1915; National Gallery of Art, Washington), he was immediately impressed, and although she was completely unknown, he exhibited her work at his famous gallery the next spring.[6] Believing he had found the woman artist for whom he had long been searching, he became O'Keeffe's dealer and most ardent advocate, organizing a solo O'Keeffe exhibition in 1917 and almost

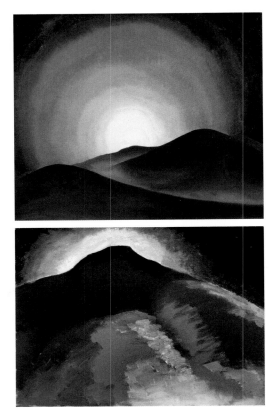

Fig. 1 Georgia O'Keeffe, *The Red Hills with Sun*, 1927
Oil on canvas; The Phillips Collection, Washington

Fig. 2 Georgia O'Keeffe, *No. 22–Special*, 1916/17
Oil on canvas; Georgia O'Keeffe Museum, Santa Fe

every year from 1923 until his death in 1946.[7] The degree of his success is best measured by the prominence O'Keeffe had achieved by the end of the 1920s as well as by the financial independence she then enjoyed as a result of his sales of her work.[8]

O'Keeffe had lived in New York as a student three times before 1918, when, at age thirty-one, she accepted Stieglitz's offer of financial support for a year and moved to the city to devote all of her energies to her work.[9] Stieglitz was over twenty years her senior and married, but as the result of letters the two began exchanging in 1916, they were already in love when she arrived in 1918. Shortly thereafter, they began living together and were married in 1924. For the next eleven years, except for brief periods when O'Keeffe was either in Connecticut, Maine, or Wisconsin, the two were nearly inseparable, living and working together winter and spring in New York City and summer and fall at the Stieglitz family compound at Lake George, in upstate New York.

In 1912–14, before beginning her life with Stieglitz, O'Keeffe had taught school in Amarillo, in the Texas Panhandle, where the seemingly endless, flat lands and expansive skies were a great source of inspiration for her work. Early in 1916, as she was considering whether or not to take another teaching position in Texas, this time in nearby Canyon, she described her feelings about the area in a letter to her friend Anita Pollitzer: "The wind blows like mad ... there is something wonderful about the bigness and the loneliness and the windiness of it all.... I've seen the most wonderful sunsets over what seemed to be the ocean."[10] She accepted the position and remained in Texas until she moved to New York.[11]

O'Keeffe was extremely productive during her first decade with Stieglitz, creating some of the works that distinguished her as an American original, such as *Red Poppy* (1927; Private Collection) and *Radiator Bldg–Night, New York* (1927; The Carl Van Vechten Gallery of Fine Arts, Fisk University, Nashville). But by 1927, after nearly a decade in and around New York, O'Keeffe found herself longing for the feeling of freedom and creative energy she had experienced in Texas. This can be seen in her painting of that year *The Red Hills with Sun* (fig. 1).[12] The forms, intensity of color, and halo of light in this presumably Lake George landscape are astonishingly

similar to those in a painting inspired by the configurations of the Palo Duro Canyon, which she explored avidly while living in Canyon (see fig. 2).

But more than anything else, O'Keeffe knew that if she were to continue to flourish as an artist, she needed a new source of inspiration for her work, which meant spending periods of time away from Stieglitz. Although he had offered to accompany her to New Mexico, he did not want to leave New York, and despite his ardent support of O'Keeffe, he found it difficult to support the idea of her not being with him.[13] But O'Keeffe was resolute in her determination and in May set out for New Mexico.

She immediately felt at home, as she pointed out that summer when writing to her friend the art critic Henry McBride: "I'm having a wonderful time. You know I never feel at home anywhere like I do out here. I finally feel in the right place again, I feel like myself again and I like it."[14] Almost two decades later, she was just as enthusiastic:

It's the most wonderful place you can imagine.... It's ridiculous. In front of my house there are low scrub brushes and cottonwood trees and, further out, a line of hills. And then I have this mountain. A flat top mountain that slopes off on each side. A blue mountain. And to the left you can see snow covered mountains, far, far away.... At the back door are the red hills and the cliffs and the sands – the bad lands. I go out of my back door and walk for 15 minutes and I am some place that I've never been before, where it seems that no one has ever been before me.[15]

Her feelings about New Mexico never changed. As she recalled in a 1977 interview: "I'd never seen anything like it before, but it fitted to me exactly."[16]

Even before Stieglitz's death, O'Keeffe was obviously intent on living in New Mexico. She purchased a house at Ghost Ranch in 1940 and another in the nearby village of Abiquiu in 1945.[17] There is no indication that she ever perceived living in New Mexico as being divorced from the art world. It was where she wanted to be and, after settling Stieglitz's estate, there was no compelling reason for her to remain in New York. Yet, she maintained an apartment there through the 1950s and visited the city frequently for business and personal reasons throughout her life, such as in 1950, when she closed Stieglitz's last gallery, An American Place, with an exhibition of her own work.[18]

That same year, Edith Halpert, who owned The Downtown Gallery and had developed a professional relationship with Stieglitz over the years, began representing O'Keeffe in New York.[19] From 1946 until their relationship ended in 1963, Halpert made O'Keeffe's work

seamlessly and easily available.[20] She always had O'Keeffe works on consignment, as well as an illustrated record of her output that potential buyers could consult; and together with the artist, she organized one-person exhibitions of O'Keeffe's work at The Downtown Gallery in 1952, 1955, 1958, and 1961.[21] Moreover, she always included a work by O'Keeffe in the numerous group exhibitions she organized every year at the gallery and encouraged the artist to lend her work to national and international exhibitions.[22]

Stieglitz helped organize the one-person retrospective exhibition of O'Keeffe's work at The Museum of Modern Art, New York, in 1946, which opened several months before his death. Thereafter, O'Keeffe herself oversaw three major retrospectives of her work: at the Worcester Art Museum, Massachusetts (1960); the Amon Carter Museum, Fort Worth (1966); and the Whitney Museum of American Art, New York (1970).[23] For all three, she exercised complete control over content and supervised the installation. In speaking of the degree to which she had been involved in the Whitney exhibition, for example, O'Keeffe pointed out: "The museum people started to hang the show chronologically … I didn't think it looked well. So I had it rearranged. I do it better than most people anyway."[24]

After Stieglitz's death, O'Keeffe's determination to control everything she could about her exhibitions found a parallel in her determination to control other components of her career, namely her public image and what was written about her art. O'Keeffe objected to the sex-based interpretations that Stieglitz imposed on her work beginning in the 1910s, for which he had provided visual equivalents in 1921 through an exhibition of his own work.[25] The exhibition included a group of closely cropped, sharp-focus photographs of a nude O'Keeffe that electrified viewers as well as several images of her in various stages of undress standing

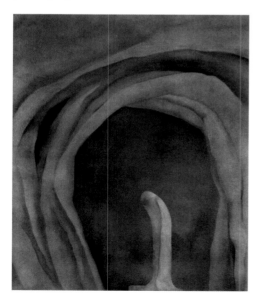

in front of and gesturing toward examples of her abstract work. These images unequivocally equated O'Keeffe's abstractions with her body, which helped forge a public image of her as an uninhibited, intuitive, unthinking, natural force whose work was a manifestation of her sexuality.[26]

Such ideas held enormous appeal for an era newly celebrating Freud, and critics who had had no previous experience with interpreting abstraction in the art of a woman, took their cue from Stieglitz and wrote about O'Keeffe's work in overwhelmingly Freudian terms.[27] Certainly, many of the sensual, highly provocative forms in her early abstractions lent themselves to such interpretations, such as the centralized form in *Blue II*

Fig. 3 Alfred Stieglitz, *Interpretation*, 1919
Palladian print; Beinecke Rare Book and Manuscript Library,
Yale University, New Haven

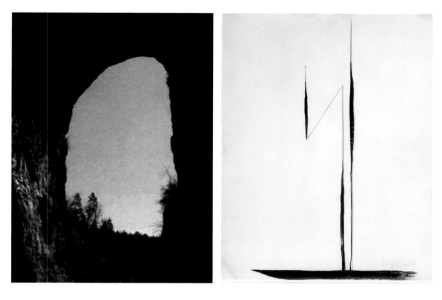

Fig. 4 *Natural Bridge in the Southern Shenandoah Valley*, n.d.
Fig. 5 Georgia O'Keeffe, *Black Lines*, 1916
Watercolor on paper; Georgia O'Keeffe Museum, Santa Fe

(plate 4). Yet, although there is little doubt that the critics read such "womblike" forms as emanating from her body, the source of this watercolor was probably very different from that perception. In fact, O'Keeffe made the work when she was intensely involved in practicing the violin, and its expressive, central spiral most probably derived from both the resonant sounds of the instrument and the scroll-shaped termination of its neck.

Another case in point are the forms in O'Keeffe's painting *Music – Pink and Blue No. I* (1918; Collection of Barney A. Ebsworth). Stieglitz sexualized this image by juxtaposing it with O'Keeffe's 1916 sculpture *Abstraction* in a photograph he made of both O'Keeffe works in 1919, *Interpretation,* 1919 (fig. 3). Although the sculpture can easily be read as phallic, it is clear that O'Keeffe conceived of it with nothing even vaguely sexual in mind. She most probably intended it as a *memento mori* for her mother, who died in 1916, and in letters Pollitzer wrote to O'Keeffe, she referred to the work as a "she."[28] Moreover, it is possible that rather than being inspired by O'Keeffe's awareness of her own body, the centralized form in this painting derived from her appreciation of a landscape configuration she had first seen in 1916: the Natural Bridge in the Southern Shenandoah Valley (fig. 4). This form obviously meant a great deal to her, because postcards she purchased of it in 1916 were in her collection at the time of her death seventy years later.

But more important, many of O'Keeffe's abstract works of the 1910s and 1920s, which seemed to personify Stieglitz's public image of her, are replete with shapes that might be seen as derived from male sexual anatomy, as in *No. 4 Special* (1915; National Gallery of Art, Washington) or *Black Lines* (fig. 5). Such shapes imbue her work with an opposing dynamic of phallic and yonic forms that often appear in the works of other abstractionists such as Arthur Dove. However, in those artists' work, forms that might be given sexual meaning were only briefly interpreted in Freudian terms.[29] Indeed, shapes that can be read as phallic continue to characterize O'Keeffe's subsequent work, particularly in the vertical buildings in her city paintings or the projecting spadices of her calla and jack-in-the-pulpit compositions. However, these forms derive from O'Keeffe's observation of sources in the visible world and directly challenge assertions that her work is a manifestation of female sexuality.

In the 1920s, O'Keeffe did not openly confront either the public image Stieglitz had created of her or his sex-based promotion of her art, because to do so would have been to challenge the individual who was making it possible for her to make her way in a world nearly exclusive of women.[30] She made clear her disapproval of the way he chose to go about promoting her work by initiating silent campaigns through which she sought to redefine herself as the opposite of an unthinking, intuitive natural force and to move critics away from gender-based readings of her art.[31] Because she felt that her abstractions had been most responsible for the critical consensus she resented, she not only limited their number in her subsequent work, but she nearly excluded them from future annual exhibitions Stieglitz organized. And, through her increasing attention to painting recognizable forms, albeit always with abstract underpinnings, she had by the mid-1920s redefined herself as a painter of representational subject matter, as she remains best known today.

Her success in controlling how her imagery was perceived, however, was limited. In much of what she subsequently painted in the 1920s, especially her large-format paintings of flowers, she used forms that are highly sensual, and it is ironic that when she set about to paint recognizable subject matter, and especially paintings in which she depicted the centers of flowers, it further precipitated Freudian readings of her work.[32] But in subsequent decades, as O'Keeffe increasingly turned her attention to subjects inspired by her experience in New Mexico, such as bones and architectural or landscape forms, Freudian interpretations nearly disappeared from the criticism. In writing about O'Keeffe's art in 1967, Eugene Goossen summed up aspects of the problem and dismissed it as irrelevant to her achievement:

O'Keeffe herself is a phenomenon, not only because she is an extraordinary artist but also because she has survived the prejudice against her sex in art. This prejudice has been used on past occasions to diminish her contributions and her role in the art history of this century, and though this is no longer true, because of the changing manners and mores of the country, it has been effective enough to require an extensive re-evaluation of her work. Sometimes she was killed by kindness, by gentlemanly politeness; other times, the excessive praise of her "feminine" qualities as a painter, combined with a misreading of her subject matter, buried the truth that she stood head and shoulders above virtually all of her colleagues, male though they might be.[33]

Yet the problem resurfaced in the criticism, albeit in new ways, in conjunction with the enormous success of O'Keeffe's 1970 Whitney retrospective. Scores of articles were written about the exhibition and about O'Keeffe, as the epicenter of the American art community

celebrated the accomplishments of one of its most celebrated artists (who was then eighty-three). On the one hand, critics reaffirmed O'Keeffe's innovations and her importance to the history of American art. But on the other, a group of feminist artists and art historians, in championing O'Keeffe as the goddess of the movement they represented, drew fresh attention to the centralized forms in O'Keeffe's work, especially those that called to mind female sexual anatomy, such as in *Black Iris* (fig. 6), and lauded them as manifestations of an iconography they considered specifically representative of the feminine.

O'Keeffe was as troubled by these readings of her art as she had been when the men had voiced similarly essentialist ideas about it beginning in the 1910s. Now, however, she was in a position to do something about it. She openly rejected what the feminists were saying about her art and refused to take part in their exhibitions or to acknowledge their ground-breaking research.[34] The irony, of course, is that O'Keeffe was a feminist. She had joined the National Woman's Party in the 1910s, then the most radical feminist organization of the day, and she maintained membership in it until its dissolution during the 1970s. But gender-based interpretations of her art, whether voiced by men or women, were unacceptable to O'Keeffe, because in her mind they limited both its meaning and significance.[35]

While O'Keeffe's new visibility in the 1970s compromised her efforts to minimize essentialist readings of her art, it greatly facilitated her ability to realize her other initiative of the 1920s – that of countering the sexualized public image of her that Stieglitz had invented. O'Keeffe silently countered it in the 1920s by increasingly presenting herself to the press and public as an aloof, uncom-

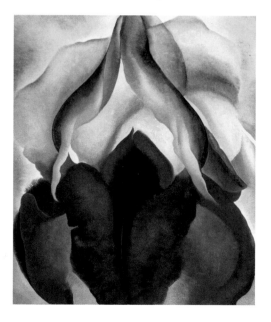

promising, and serious individual, whose primary concern was her work.[36] This persona became increasingly persuasive in subsequent decades as O'Keeffe began presenting herself as a willing inhabitant of the Southwest's exotic, harsh, and unforgiving environment. That is, after her move to New Mexico, she increasingly applied what she had learned about self-promotion from Stieglitz to define herself in her own way and on her own terms. To achieve this, she allowed portraits to be made of her by various photographers, such as Yousuf Karsh, Todd Webb, Philippe Halsman, and Arnold Newman, and began agreeing to interviews for popular and widely distributed publications, such as *Atlantic*, *House Beautiful*, *House and Garden*, *Life*, *Look*, *The New Yorker*, *Newsweek*, and *Vogue*.[37]

Fig. 6 Georgia O'Keeffe, *Black Iris*, 1926
Oil on canvas; The Metropolitan Museum of Art, New York

In fact, as early as 1960, an article in *Newsweek* describes the character of her simple environment and lifestyle exactly as O'Keeffe wished: "She moved permanently to the little town of Abiquiu (population 400), about 50 miles north of Santa Fe. There she lives with her four dogs and two cats in an ancient, fortress-like adobe house overlooking the Rio Chama valley.... 'My world is very different.... It's very bare, very empty. It sprawls all over the world.'"[38]

Subsequent publications in the 1960s, with titles such as "The Austerity of the Desert Pervades Her Home and Her Work" or "Georgia O'Keeffe in New Mexico: Stark Visions of a Pioneer Painter ..." include pictures of her in her environment by other photographers, such as Laura Gilpin, Ralph Looney, Balthazar Korab, John Loengard, Tony Vaccarro, or Cecil Beaton. These images provide tantalizing glimpses of her severe manner of dress and of the austere and uncompromising landscape forms through which she walked (fig. 7). Some present her in the minimalist surroundings of her sparsely furnished houses.[39]

These publications set the stage for descriptions of the artist that accompanied responses to the Whitney exhibition at nearly the same time that essentialist ideas resurfaced with new vigor in the criticism of her art. In 1970, for example, in an article published

in *Time* titled "Loner in the Desert," Robert Hughes wrote: "O'Keeffe appropriated the 19th century image of the Pioneer Woman (as Pollock took that of the Roaring Boy) and, against all odds, made it work. Wrinkled and spry, fiercely committed to work and solitude, she lives isolated on her New Mexico ranch with two servants and a pair of eleven-year-old chow dogs for company ... a paradigm of the frontier experience which Thoreau tried with less success to live at Walden."[40] Or as Bill Marvel pointed out that same year in an article for *The National Observer*:

She is a strange sight, striding through the sagebrush in a long black dress followed by two old charcoal-colored chow dogs.... She is about the only Anglo hereabouts.... The dogs and the high adobe wall surrounding the house protect Miss O'Keeffe from intrusions.... Miss O'Keeffe values her privacy.... There is something austere and essential about the woman herself as well, with her beautiful, lined face and her strong, feminine hands. Standing in the midst of the desert she surveys her Ghost Ranch retreat and remarks, "When I first moved here the roads weren't paved and there was no electricity, no telephone."[41]

Fig. 7 John Loengard, *Evening Walk, Ghost Ranch*, 1966
Gelatin silver print; Time Life Pictures/Getty Images

Fig. 8 Yousuf Karsh, *Georgia O'Keeffe*, 1956
Gelatin silver print; Georgia O'Keeffe Museum, Santa Fe

This image of O'Keeffe in what over the years came to be known as "O'Keeffe country" was increasingly reinforced during subsequent decades by a procession of writers and photographers carefully selected by O'Keeffe and invited to Abiquiu to document what her life had become after the New York years, such as Grace Glueck, Lawrence Alloway, Calvin Tomkins, and Malcolm Varon. She allowed the making of a documentary film about her life and art that was produced by Perry Miller Adato and aired on American public television in 1977. Because of the way the aging artist lived and dressed, how she presented herself to those with whom she chose to work and speak, as well as what she said to them about her life and work, O'Keeffe soon came to be known as a courageous, self-disciplined pioneer, whose artistic success was the result of self-imposed isolation and hard work.

This is precisely the persona that emerged from O'Keeffe's own lengthy and beautifully produced book *Georgia O'Keeffe* (1976), whose single mention of Stieglitz could be interpreted as an attempt to erase the significance of the role he had played in her success, and because the book is partly autobiographical, to effectually remove Stieglitz from her life (fig. 8). But in 1978, thirty years after his death, in a way that could be seen as repaying an old debt, O'Keeffe organized and underwrote the first major posthumous exhibition of Stieglitz's work, held at The Metropolitan Museum of Art, New York. And she similarly organized and underwrote another major Stieglitz show at the National Gallery of Art, Washington, in 1983. Just as O'Keeffe's fame was initially achieved through Stieglitz's promotional efforts in New York, his importance today can be attributed in part to O'Keeffe's campaign in the final years of her life to rejuvenate interest in his work.[42] These activities can hardly be seen as the work of someone attempting to eradicate the memory of an early, important champion and life-long friend and influence.

O'Keeffe's success at reversing the early career public image of herself as a highly charged sexual creature whose art was a manifestation of her gender is best summed up in an article published in *The New Yorker* in 1978: "Her painting, with its images of romantic isolated purity, became an embodiment of an individual who was strong enough to live out her life exactly as she wanted to.... For many Americans, especially in the twenties, thirties, and forties, O'Keeffe was a living symbol of self-assertion – not belligerently or anxiously, or with Pollock's tragic excessiveness, but with a mild, unflappable, resolute integrity."[43] In presenting

Fig. 9 Alfred Stieglitz, *Georgia O'Keeffe: A Portrait-Head*, 1918
Gelatin silver print; The Metropolitan Museum of Art, New York

herself as an exemplar of the American dream of self-realization, she had deliberately crafted a public image that differed vastly from but was as pervasive as the one Stieglitz had presented in the 1920s (fig. 9).

Yet all public images are at least in part mythic, and O'Keeffe's is no exception. Her life in New Mexico was as full as she wished it to be, and she was never really alone. She frequently entertained friends from all over the world, some of whom stayed at one of her houses for weeks at a time, and she surrounded herself with a retinue of assistants.[44] Furthermore, she was hardly confined to New Mexico, but traveled as often and extensively as she wished, always in the company of friends. In fact, the illusion she created of herself as a self-sufficient loner was so complete that the woman who was seldom photographed smiling must have smiled frequently to herself.

Was O'Keeffe's move to New Mexico a rejection of New York? Strictly speaking, yes. But it could never be perceived as an attempt to isolate herself from the larger art community: she was able to control aspects of her career more effectively in New Mexico than she had in New York. Her work was exhibited as frequently as she wished it to be, and it developed in ways that might not have occurred had she remained in New York. She moved to New Mexico because it provided what she needed; and especially in the early years there, she underwent extraordinary trials to maintain herself, including, for example, having to drive thirty miles on unpaved roads to buy a head of lettuce.[45] But she was determined to prevail, and she did. Living in what many people still define as self-imposed isolation made it possible for her to control everything she held dear: her career, her life, and her public image.

Had O'Keeffe not been so enamored of the wide-open spaces of the American Southwest early on and had she not objected so strongly to early interpretations of her work and the resulting effect of these on her public persona, it is likely that our perception of her today would be vastly different. As it is – and unlike with most of her contemporaries – O'Keeffe will be forever associated with a specific region of the country, not with the city that was the setting of her extraordinary early success, and she will be forever associated with the image she chose to build for herself late in her career, which established her identity as an American original, not as the sensational sexual creature that ironically contributed in large measure to her early renown.

1 See Barbara Buhler Lynes, *O'Keeffe, Stieglitz and the Critics, 1916–1929* (Chicago: University of Chicago Press, 1991), pp. 149–50.

2 The recently unsealed Georgia O'Keeffe/Alfred Stieglitz correspondence referred to here as OK/AS is part of the Georgia O'Keeffe/Alfred Stieglitz Archive housed at the Beinecke Rare Book and Manuscript Library, Yale University. It provides extensive information about the complexity of O'Keeffe's state of mind in the late 1920s regarding her work, her relationship with Stieglitz, and her desire to find a place to work other than at Lake George, where she was constantly interrupted by visitors and distracted by problems with her own or Stieglitz's health. The letters contradict what a number of O'Keeffe biographers have supposed: that O'Keeffe went to New Mexico in 1929 primarily as a result of Stieglitz's increasing infatuation with his friend Dorothy Norman, whose acquaintance he had made in 1927. Letters from O'Keeffe to Stieglitz indicate that she had tried in vain to secure a studio away from Lake George in the late 1920s, and letters from Stieglitz to O'Keeffe refer to her wanting to spend the summer of 1929 either in Europe or New Mexico. See Alfred Stieglitz to Georgia O'Keeffe, May 16, 1929; July 6, 1929; July 9, 1929; July 13, 1929; and August 5, 1929, *in* OK/AS.

3 O'Keeffe traveled by train to New Mexico with her friend Rebecca Strand, the wife of photographer Paul Strand. O'Keeffe had visited Santa Fe briefly in early summer 1917, on her return to Texas from vacationing in Colorado.

4 When she was attending the The Art Students League, O'Keeffe visited Stieglitz's gallery, 291, to see the 1908 exhibition of Auguste Rodin watercolors. She saw Stieglitz then, but did not meet him until 1916.

5 See Lynes, *O'Keeffe, Stieglitz*, pp. 5–6; and Kathleen Pyne, "Response: On Feminine Phantoms: Mother, Child, and Woman-Child," *Art Bulletin* 88 (March 2006), pp. 44–61.

6 The exhibition at 291, from May 23 to July 5, 1916, *Georgia O'Keeffe – C. Duncan –, Réné* [sic] *Lafferty*, included ten O'Keeffe charcoal drawings.

7 Stieglitz organized solo O'Keeffe exhibitions except in 1925, when he included her work in the group exhibition *Alfred Stieglitz Presents Seven Americans: 159 Paintings, Photographs & Things, Recent & Never Before Publicly Shown, by Arthur G. Dove, Marsden Hartley, John Marin, Charles Demuth, Paul Strand, Georgia O'Keeffe, Alfred Stieglitz* at The Anderson Galleries, New York (March 9–28, 1925).

8 By the end of the 1920s, in today's dollars, O'Keeffe had become almost a millionaire. See Lynes, *O'Keeffe, Stieglitz*, p. 340, n. 2. Letters from Stieglitz detail that he had generated $80,000 for O'Keeffe in 1928, which today would be approximately $900,000. See Stieglitz to O'Keeffe, July 6, 1929, in OK/AS.

9 O'Keeffe began teaching in Canyon, Texas, in fall 1916. She became ill late in 1917. In February 1918, she decided to take a leave of absence and moved to the warmer climate of San Antonio in an effort to avoid catching the flu that devastated the American population that year.

10 See Georgia O'Keeffe to Anita Pollitzer, January 14, 1916, in *Lovingly Georgia: The Complete Correspondence of Georgia O'Keeffe & Anita Pollitzer*, intro. by Benita Eisler (New York: Simon & Schuster, 1990), p. 123.

11 By March 1918, O'Keeffe had moved to Waring, Texas.

12 Stieglitz also interpreted this picture as a sign of O'Keeffe's desire to return to the Southwest. See Stieglitz to O'Keeffe, July 6, 1929, in OK/AS.

13 In late spring 1928, Stieglitz injured his hand and at the end of the summer suffered an angina attack. Although his letters suggest his willingness to accompany O'Keeffe to the Southwest in 1929, they also indicate that he had been advised by his doctor not to be in high-altitude areas. Yet, Stieglitz became increasingly fearful of losing O'Keeffe, and in late July, offered to travel to Albuquerque to see her – a trip that never materialized. See Stieglitz to O'Keeffe, July 6, 1929 and July 27, 1929, in OK/AS.

14 Georgia O'Keeffe to Henry McBride, summer 1929, in Jack Cowart, Juan Hamilton, and Sarah Greenough, *Georgia O'Keeffe: Art and Letters* (Washington: National Gallery of Art, 1987), letter 44.

15 See Carol Taylor, "Lady Dynamo – Miss O'Keeffe, Noted Artist, Is a Feminist," *New York World Telegram*, March 31, 1945, section 2, p. 9.

16 See Diana Loercher, "She Paints Questions in the Desert: The Powerful, Puzzling Art of Georgia O'Keeffe," *Christian Science Monitor*, November 14, 1977, p. 27.

17 Both of these properties are now owned by the Georgia O'Keeffe Museum, Santa Fe.

18 The exhibition was *Georgia O'Keeffe: Paintings 1946–1950* (October–November 1950).

19 Stieglitz began working with Halpert in the mid-1920s, when he loaned an O'Keeffe picture to an exhibition at her gallery (May 31–October 9, 1925).

20 The notebooks were developed by Halpert and O'Keeffe from records O'Keeffe kept of her work in her studio in Abiquiu, New Mexico, which were compiled from the Whitney Archive by Doris Bry, who was also O'Keeffe's agent from the mid-1960s through the mid-1970s. They are now part of the collection of the Georgia O'Keeffe Museum Research Center, Santa Fe. For a history of how these records were established, see Barbara Buhler Lynes, *Georgia O'Keeffe: Catalogue Raisonné* (New Haven and London:

Yale University Press, National Gallery of Art, and the Georgia O'Keeffe Foundation, 1999), pp. 14–16.

21 These exhibitions were *O'Keeffe Paintings in Pastel: 1914 to 1952* (February 19–March 8, 1952); *O'Keeffe Exhibition: New Paintings* (March 29–April 23, 1955); *Georgia O'Keeffe: Watercolors, 1916–17* (February 25–March 22, 1958); and *Georgia O'Keeffe: Recent Paintings and Drawings* (April 11–May 6, 1961).

22 The correspondence between Halpert and O'Keeffe, which reveals the highly developed managerial skills of both women, is now available online through the Archives of American Art website. See Downtown Gallery Records, 1824–1974, www.aaa.si.edu/collections/digitalcollections/ collectionsonline/ downgall/html series2.html. Artist Files, A - Z, 1917–1970, Reel 5550: 802–1234; and Reel 5551: 6–478.

23 *Georgia O'Keeffe*, The Museum of Modern Art (May 14–August 25, 1946); *Georgia O'Keeffe: Forty Years of Her Art*, Worcester Art Museum (October 4–December 4, 1960); *Georgia O'Keeffe: An Exhibition of the Work of the Artist from 1915 to 1966*, Amon Carter Museum (March–May 1966); *Georgia O'Keeffe*, Whitney Museum of American Art (October 8–November 29, 1970). Bry helped O'Keeffe greatly with the Whitney show.

24 See Nessa Forman, "Georgia O'Keeffe and Her Art: 'Paint What's in Your Head,'" *Philadelphia Bulletin*, October 22, 1971, n. p.

25 *An Exhibition of Photography, by Alfred Stieglitz [145 Prints, Over 128 of Which Have Never Been Publicly Shown, Dating from 1886–1921]*, opened February 7, 1921, at The Anderson Galleries, New York.

26 See Lynes, *O'Keeffe, Stieglitz*, pp. 27–53. The degree to which O'Keeffe collaborated with Stieglitz in making these photographs has been the subject of much debate. The following description of his working methods by his niece, Georgia Englehard Cromwell, who posed for him often in the 1910s and early 1920s, suggests that the process of making photographs of O'Keeffe was anything but a collaboration. Cromwell stated: "Frankly my recollections of posing for Alfred were a minor version of hell.... He was terribly intense and exacting – and everything about the pose had to be just so down to the position of your thumbnail.... There was no conversation except rather barked commands to do this or that with your hands, your head ... and he could get quite upset and a bit gruff if you didn't instantly comply." Georgia Englehard Cromwell to William Iness Homer, December 15, 1970, in William Iness Homer Archive, Georgia O'Keeffe Museum Research Center, Santa Fe. And in 1977, Engelhard wrote: "He portrayed the sitter as he saw him, not as the sitter wished to appear." Cromwell to Homer, January 7, 1977, in ibid.

27 Such interpretations dominated the criticism of the first O'Keeffe retrospective that Stieglitz organized in 1923, *Alfred Stieglitz Presents 100 Pictures: Oils, Watercolors, Pastels, Drawings, by Georgia O'Keeffe, American*, The Anderson Galleries, New York (January 29–February 10, 1923). For reprints of these reviews, see Lynes, *O'Keeffe, Stieglitz*, pp. 184–97. Also see Marcia Brennan, "*Painting Gender, Constructing Theory: The Alfred Stieglitz Circle and American Formalist Esthetics* (Cambridge, Massachusetts: The MIT Press, 2001).

28 See Pollitzer to O'Keeffe, June 18, 1916, in *Lovingly Georgia*, p. 158.

29 For a discussion of how Marin was perceived at mid-career, see Johathan Weinberg, "Why Marin?," *Block Points (The Annual Journal and Report of the Mary and Leigh Block Gallery, Northwestern University)* 1 (1993), pp. 20–33.

30 O'Keeffe first made public her objections to sex-based interpretations of her art in what she wrote for the brochure of her exhibition *Georgia O'Keeffe: Exhibition of Oils and Pastels*, at An American Place, New York (January 22–March 17, 1939).

31 See Lynes, *O'Keeffe, Stieglitz*.

32 For an interpretation of O'Keeffe's objective in portraying the large-scale flower paintings, whose centers usually contain both male and female sexual parts, as most flowers are androgynous. See Barbara Buhler Lynes, "Say It with Flowers," in Barbara Buhler Lynes with Heather Hole, Neil Printz, and John Smith, *Moments in Modernism – Georgia O'Keeffe and Andy Warhol: Flowers of Distinction* (Santa Fe: Georgia O'Keeffe Museum, 2006), pp. 7–13.

33 E. C. Goossen, "O'Keeffe – Her Extraordinary Contribution to Twentieth-Century Art ... Obscured by Her Fame,'" *Vogue* 149 (March 1967), p. 174.

34 See Linda Nochlin, "The Twentieth Century: Issues, Problems, Controversies," in Ann Sutherland Harris and Linda Nochlin, *Women Artists: 1550–1950* (New York: Alfred A. Knopf, 1977), p. 59, n. 209. O'Keeffe also would not allow Lawrence Alloway to reproduce six of her paintings in a late-decade article that examined, among other things, Judy Chicago's and Miriam Schapiro's interpretations of her work. See Lawrence Alloway, "Author's Note," in "Notes on Georgia O'Keeffe's Imagery," *Womanart* 1 (Spring-Summer 1977), p. 18. See also Barbara Buhler Lynes, "O'Keeffe and Feminism: A Problem of Position," in *The Expanding Discourse: Feminism and Art History*, ed. Norma Broude and Mary D. Garrard (New York: HarperCollins, 1992), pp. 436–49.

35 See Lynes, "O'Keeffe and Feminism."

36 See Lynes, *O'Keeffe, Stieglitz*.

37 See Ralph Looney, "Georgia O'Keeffe," *Atlantic* 215, 4 (April 1965), pp. 106–13; Laura Gilpin, "The Austerity of the Desert Pervades Her Home and

Her Work," *House Beautiful* 105 (April 1963), pp. 144–45, 198–99; "Georgia O'Keeffe in New Mexico: Stark Visions of a Pioneer Painter, Horizons of a Pioneer," *Life* 64 (March 1, 1968), pp. 40–49; Charlotte Willard, "Women of American Art: Their Work May Yet Equal the Best of America's Male Artists," *Look Magazine*, September 27, 1960, pp. 70–71; "Five Famous Artists in Their Personal Background," *House and Garden* 128, 6 (December 1965), pp. 176–77; Robert M. Coates, "The Art Galleries," *The New Yorker* 37, 10 (April 22, 1961), pp. 160, 163; Goossen, pp. 174–79, 221, 224.

38 See "My World Is Different," *Newsweek* 56, 15 (October 10, 1960), p. 101.

39 Gilpin's article for *House Beautiful* was illustrated with her photographs; *Life* with photographs by Loengard; *Atlantic* with photographs by Looney; *House and Garden* with photographs by Korab; *Look* with photographs by Vaccarro; and *Vogue* with photographs by Beaton.

40 Robert Hughes, "Loner in the Desert," *Time*, October 12, 1970, p. 64.

41 See Bill Marvel, "Georgia O'Keeffe's World: She Re-Creates an Awesome Nature," *The National Observer*, October 19, 1970, p. 9. The article also includes a photograph of O'Keeffe by Marvel.

42 Stieglitz became increasingly unknown toward the end of his life to the point that O'Keeffe had trouble finding an institution that would accept his photographs. See Barbara Buhler Lynes and Anne Paden, eds., *Maria Chabot/Georgia O'Keeffe: Correspondence, 1941–49* (Albuquerque: University of New Mexico Press, 2003), pp. 403, 410, 418, 435, 438, 441, 445–47, 450, 456, 462, 466, 473, 477, 481–82.

43 Sanford Schwartz, "Books: Georgia O'Keeffe Writes a Book," *The New Yorker*, August 28, 1978, p. 88.

44 O'Keeffe often refers to her guests and assistants in the countless letters she wrote to friends after moving to New Mexico. See Georgia O'Keeffe/Alfred Stieglitz Archive, Beinecke Rare Book and Manuscript Library, Yale University.

45 For a discussion of the difficulties of O'Keeffe's life in northern New Mexico in the 1940s, see Lynes and Paden.

PLATES GEORGIA O'KEEFFE

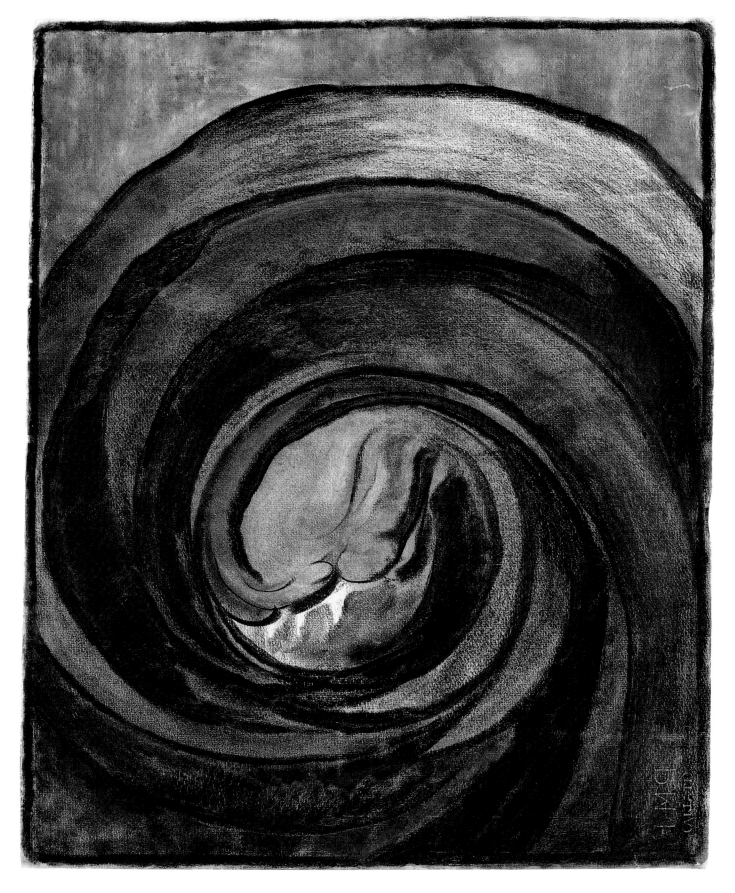

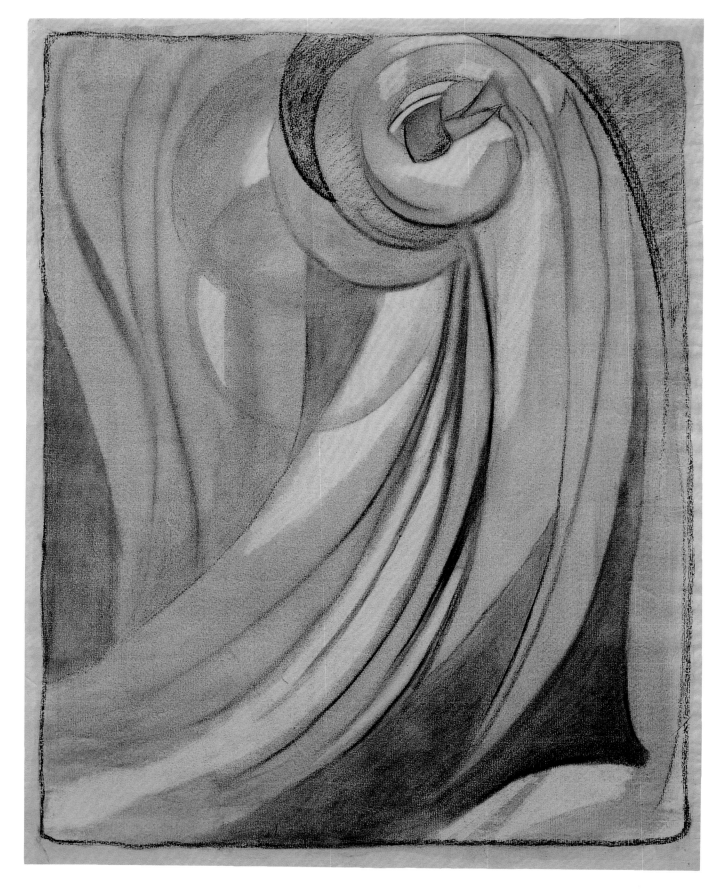

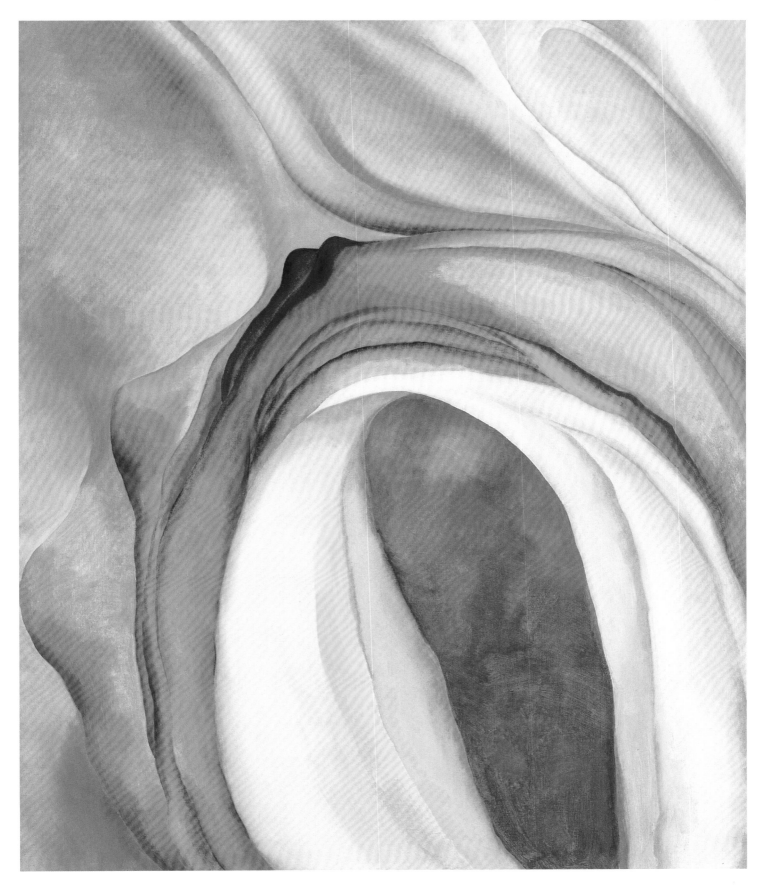

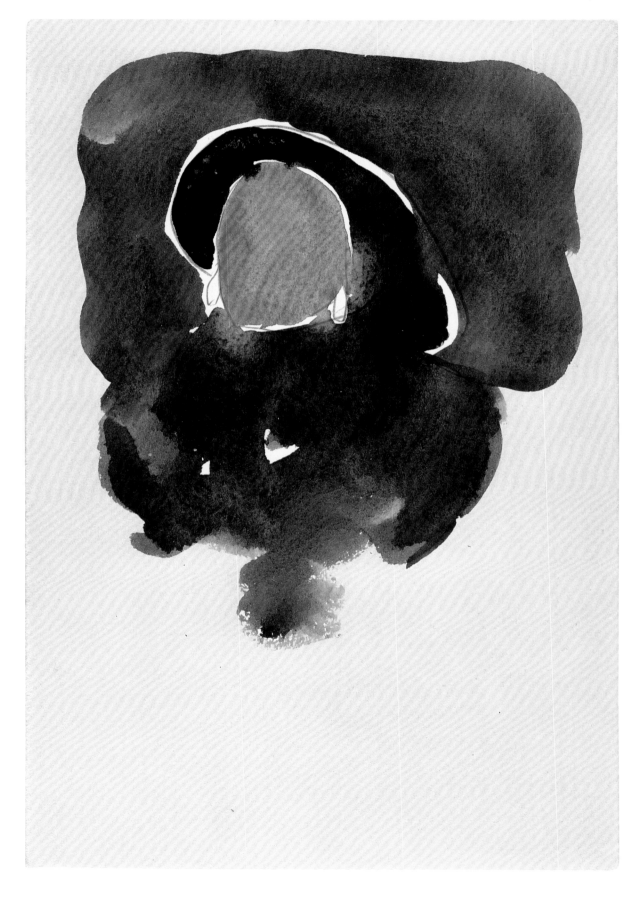

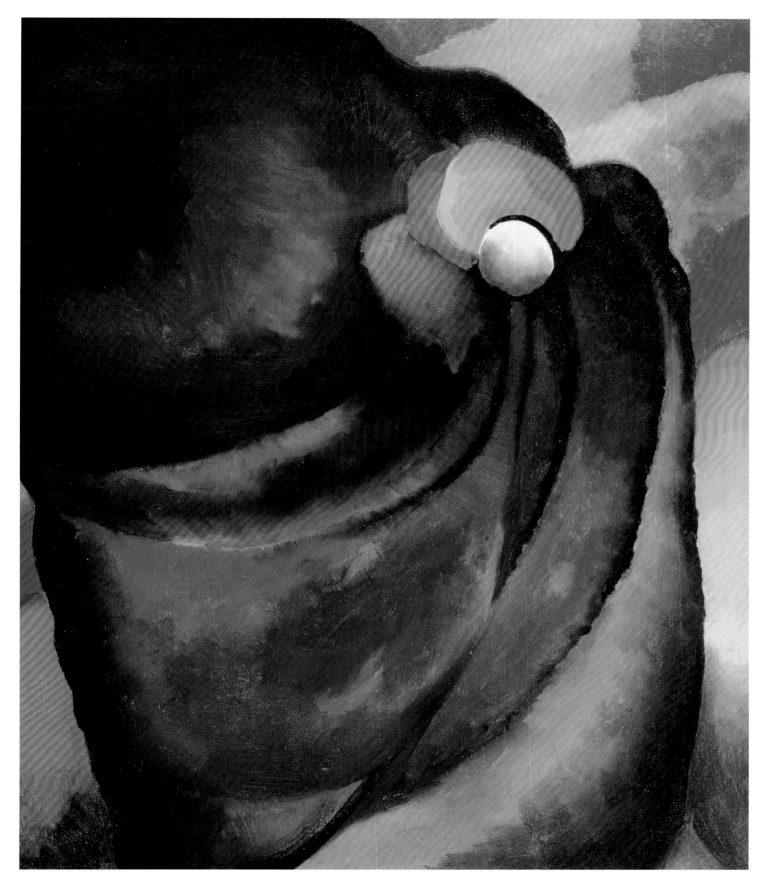

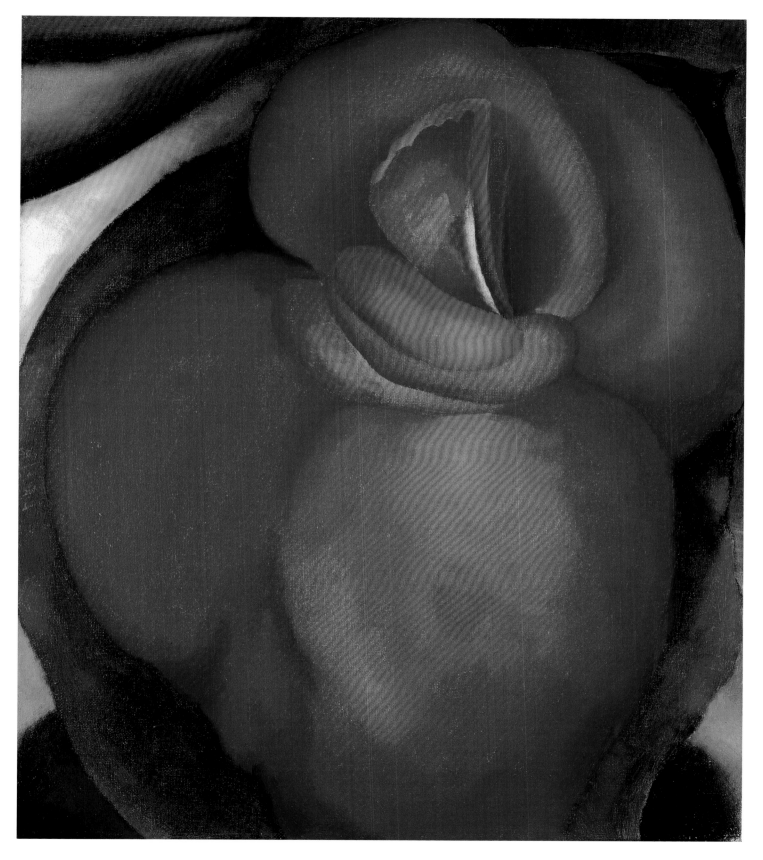

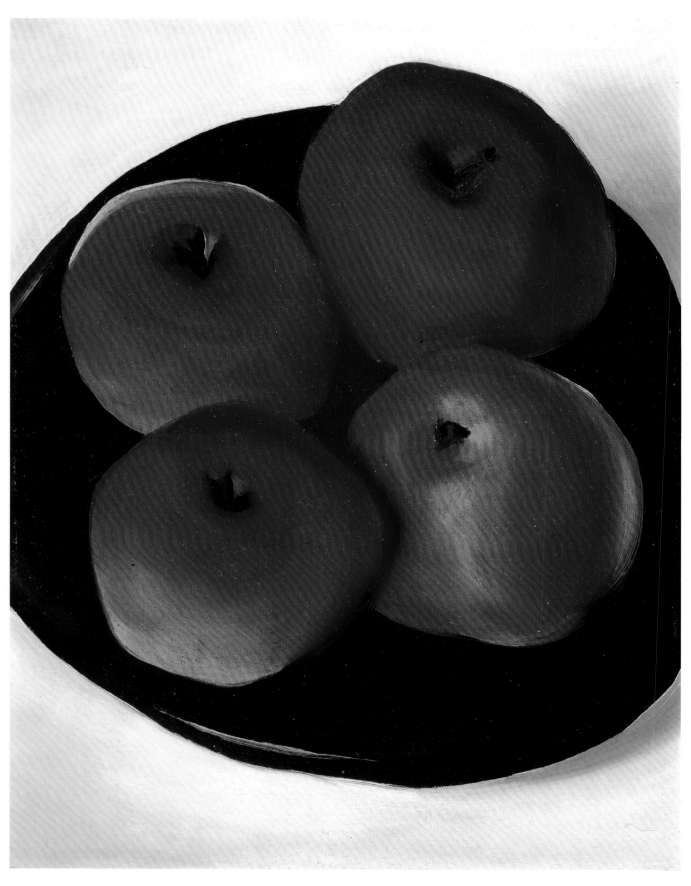

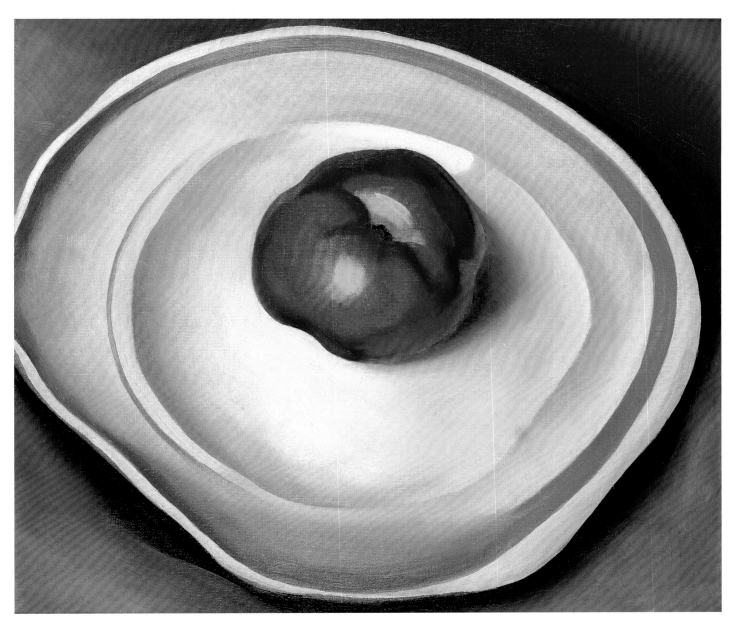

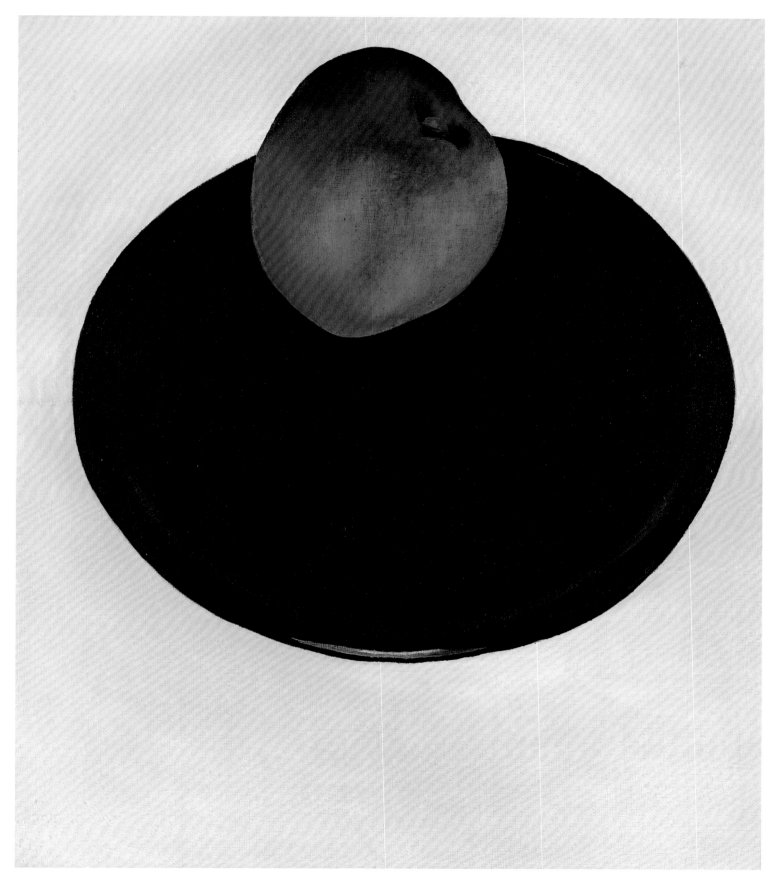

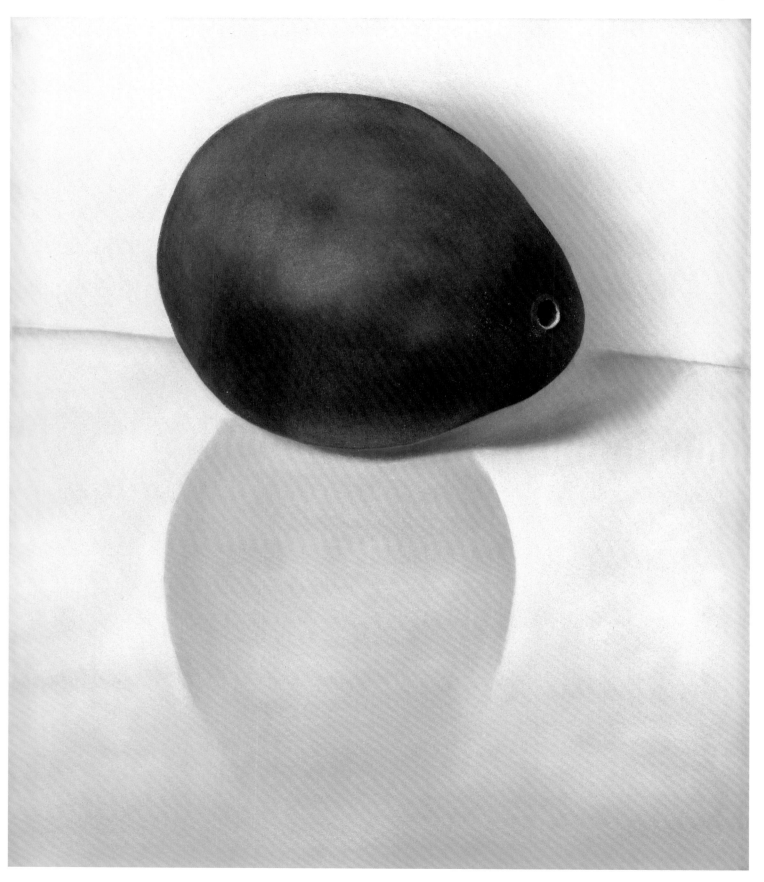

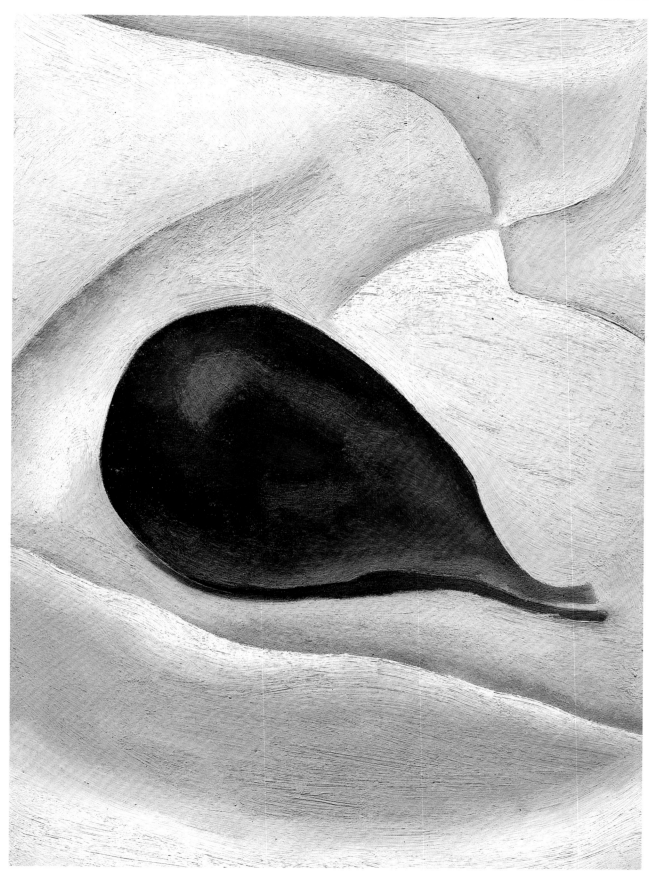

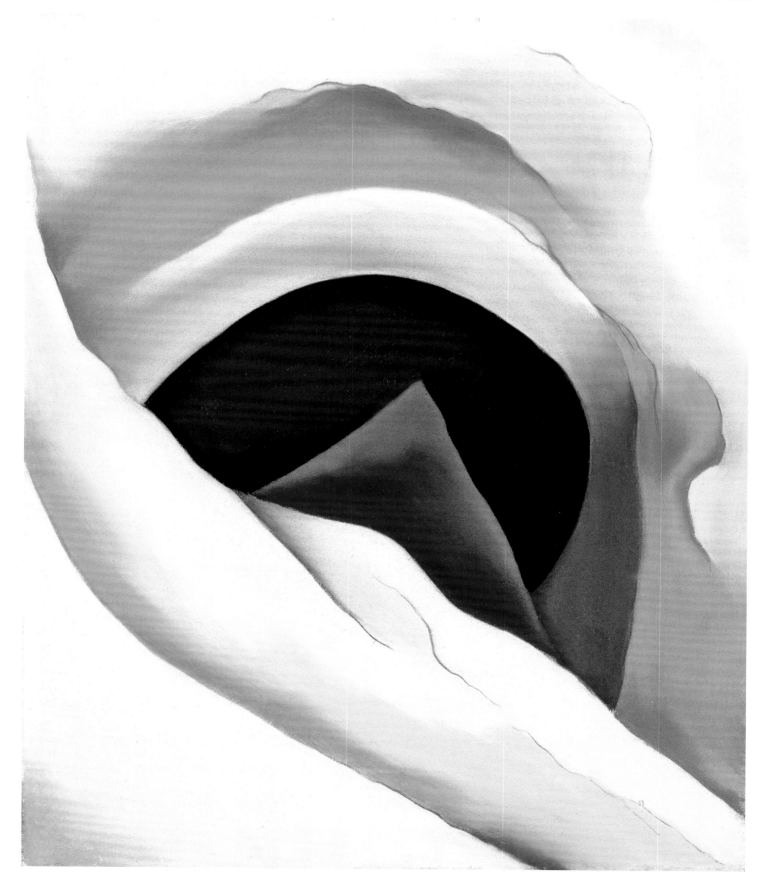

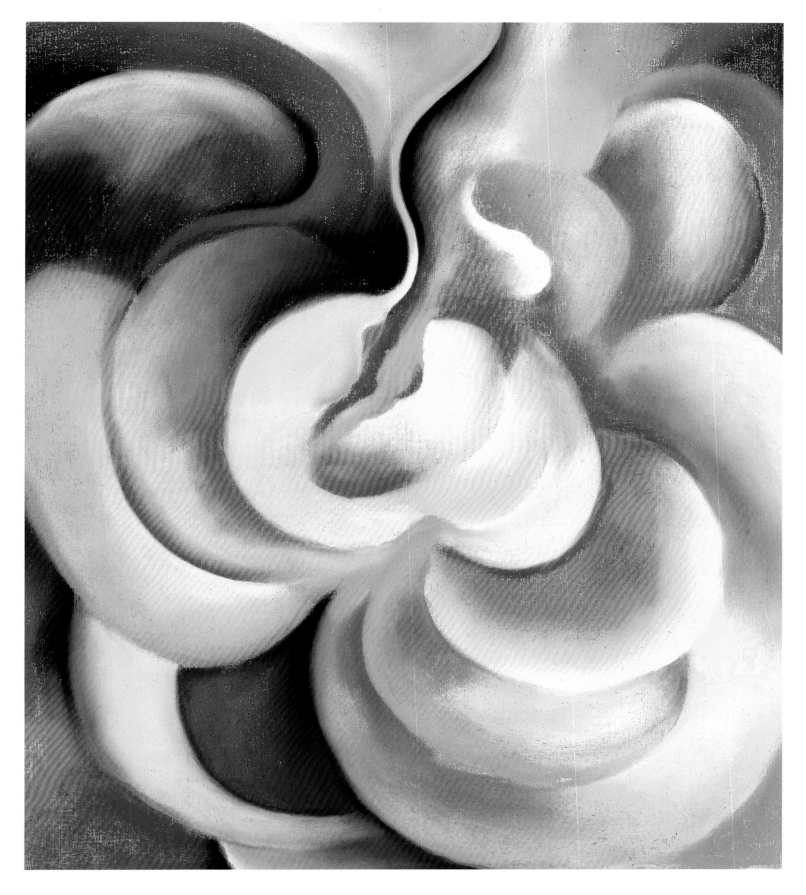

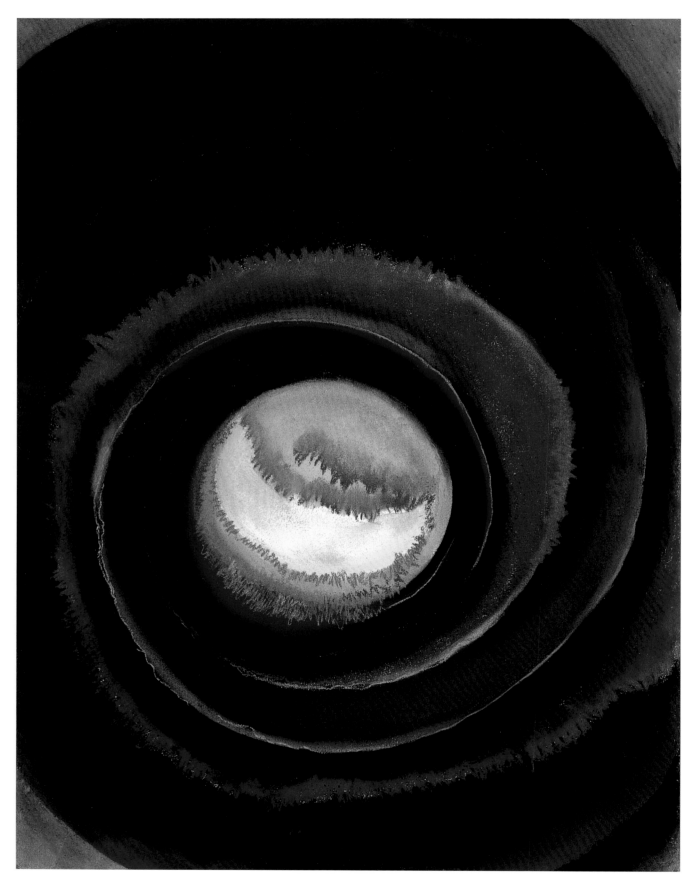

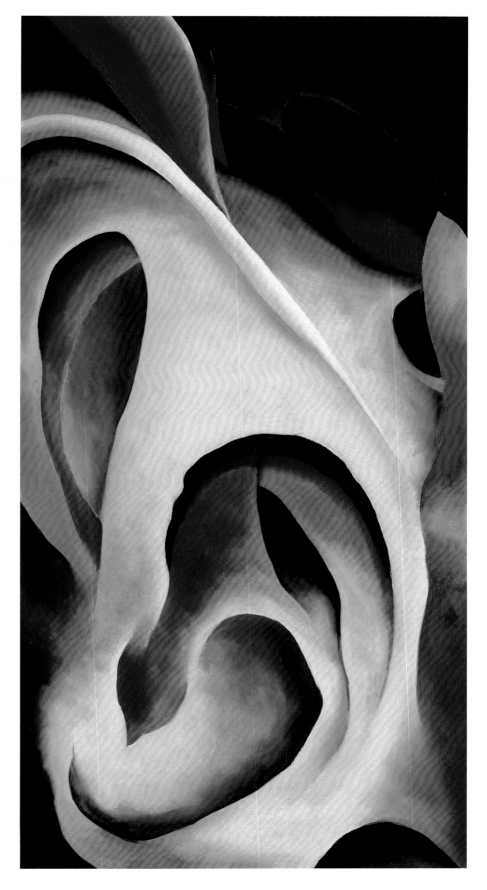

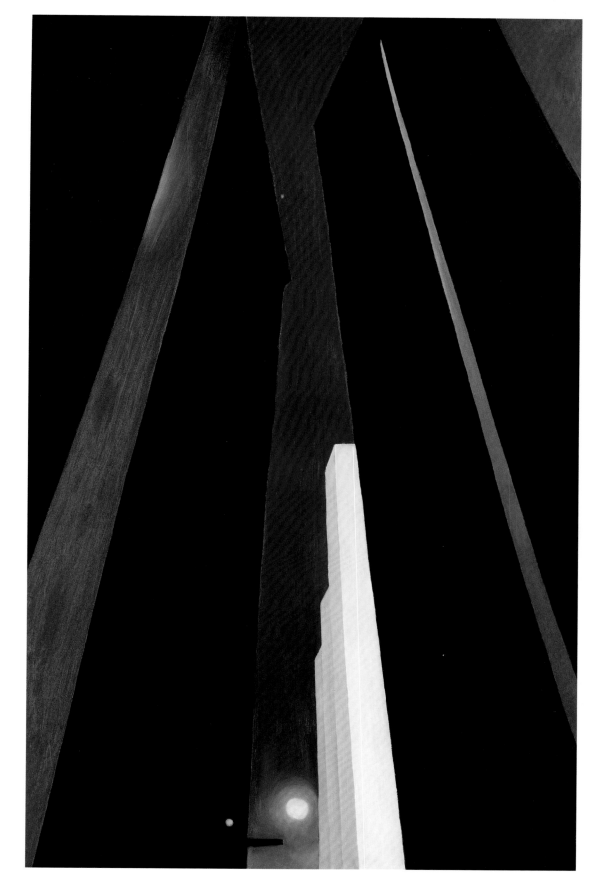

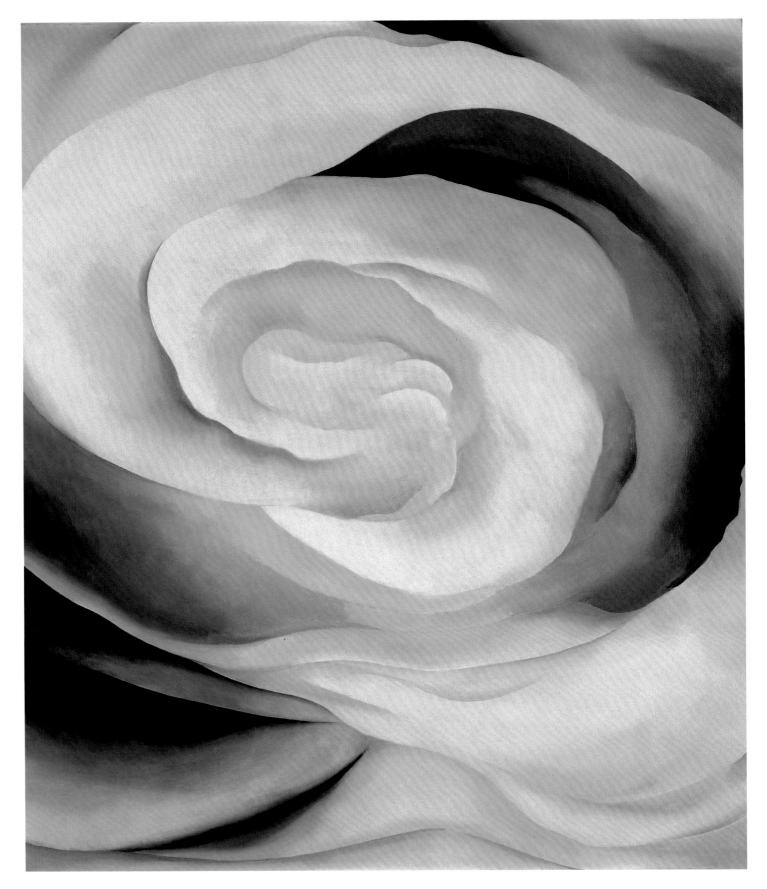

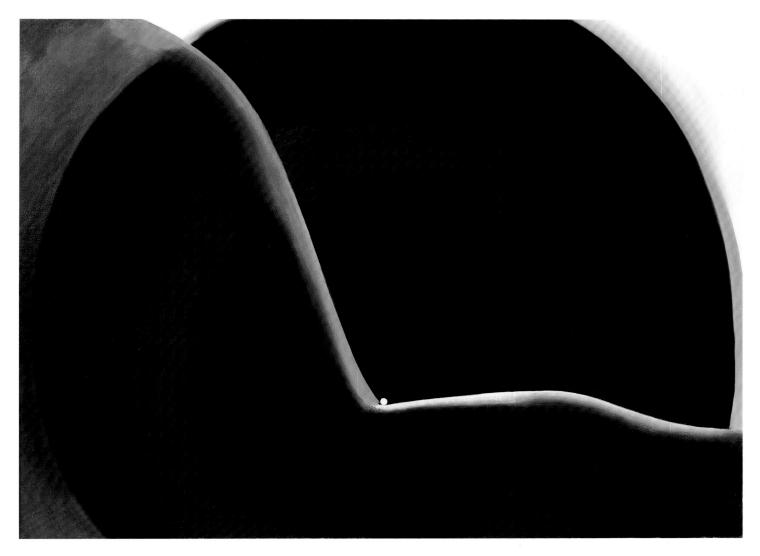

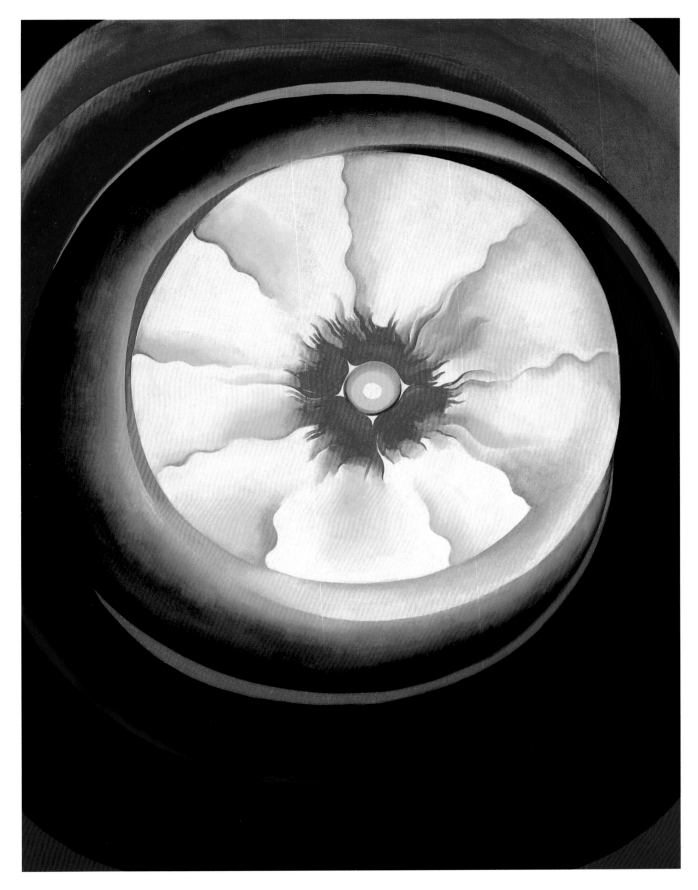

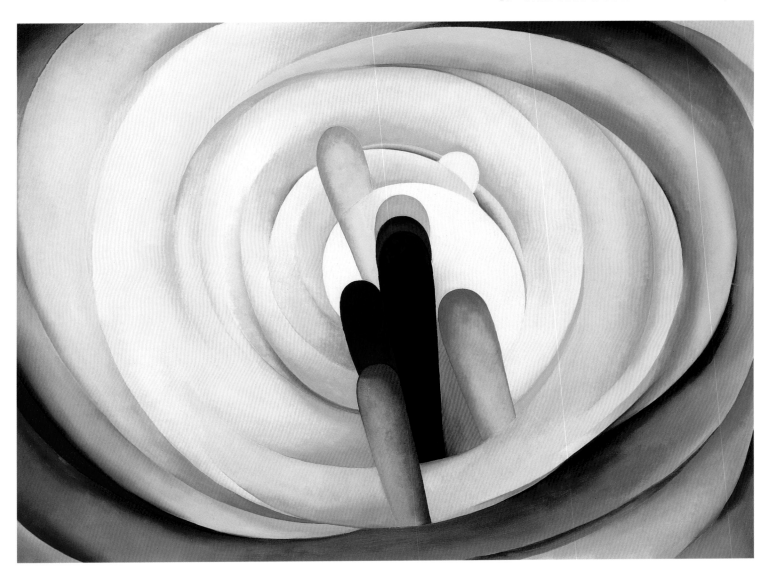

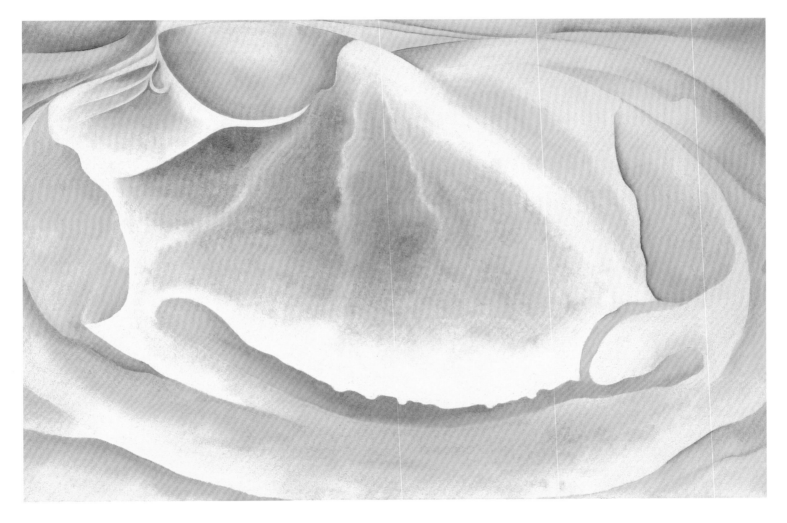

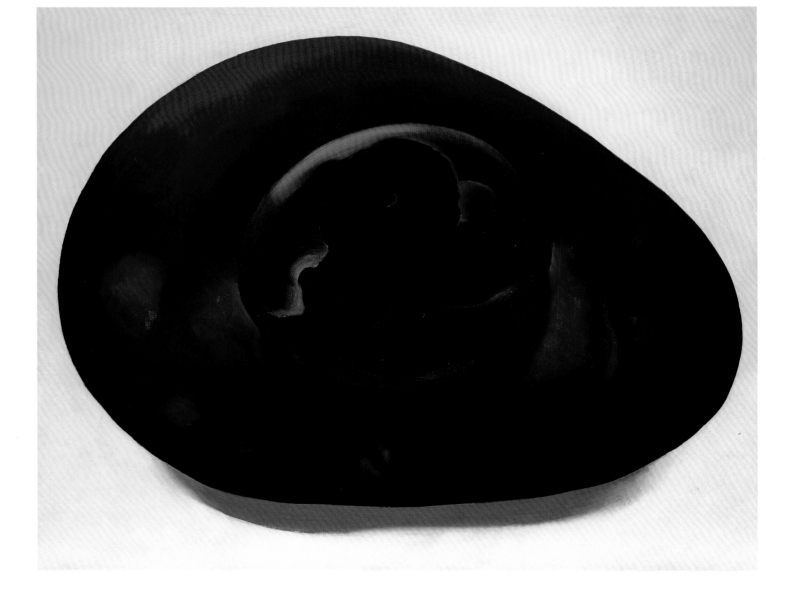

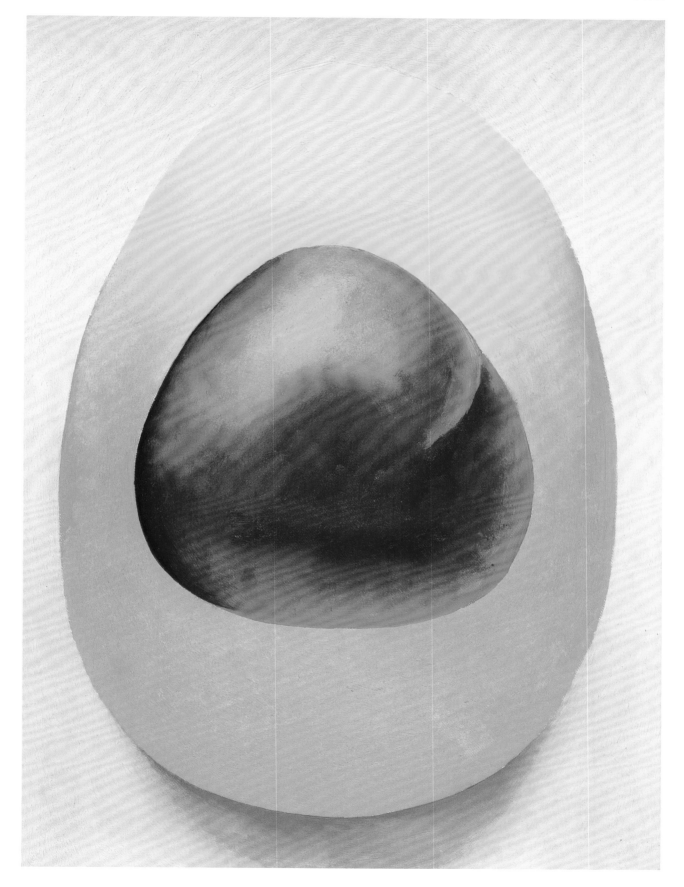

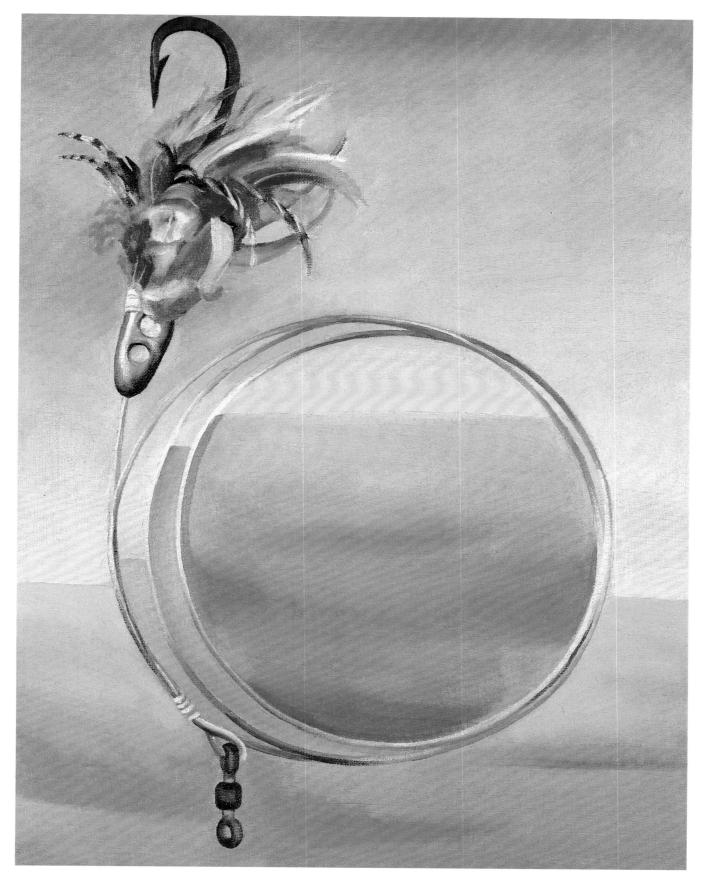

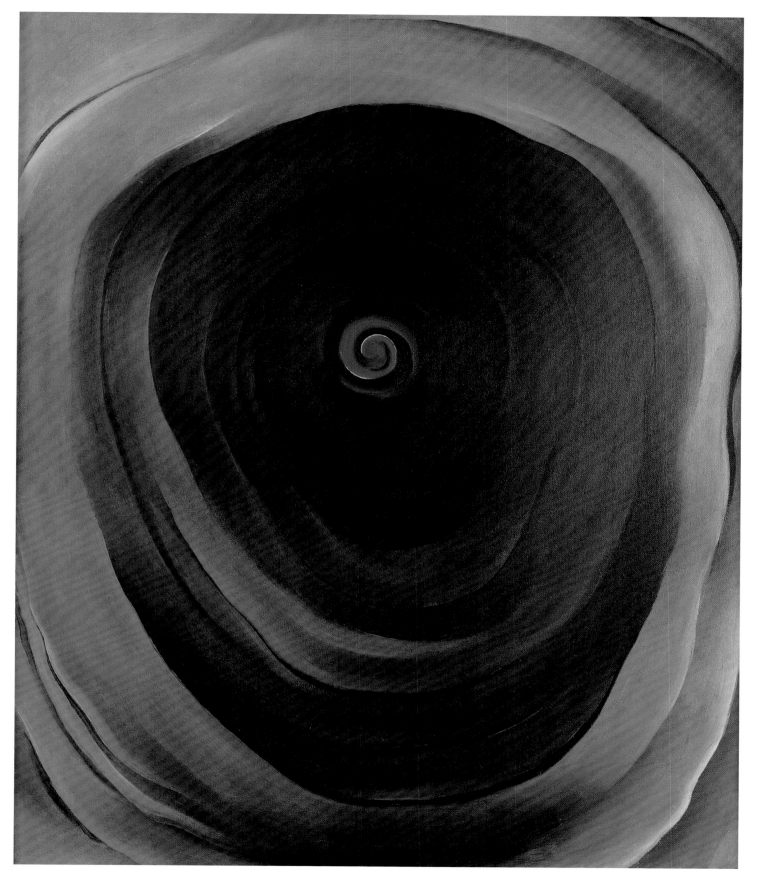

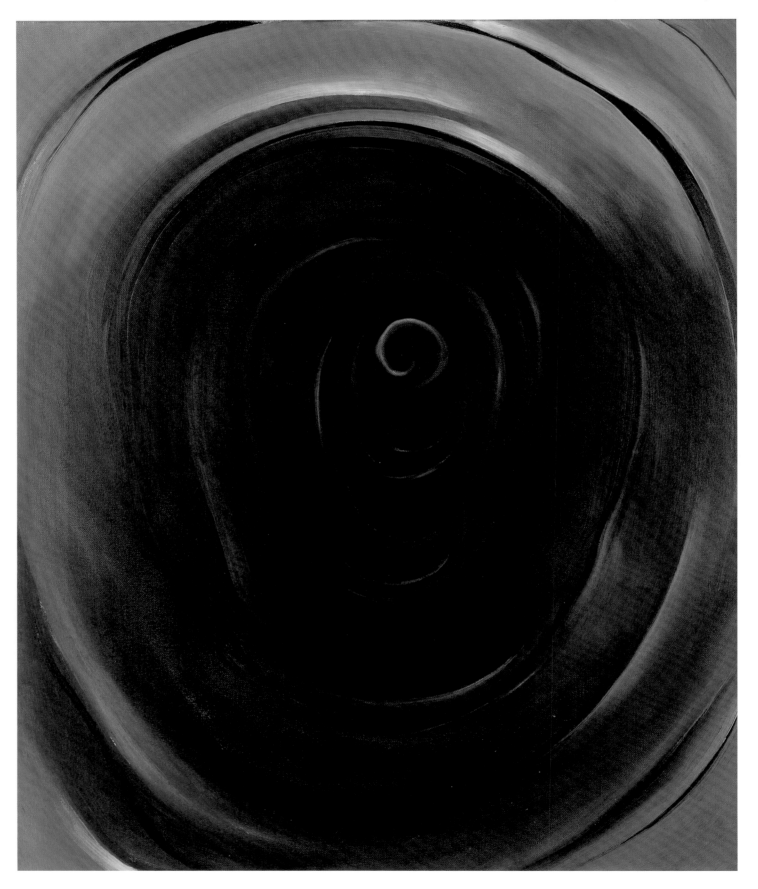

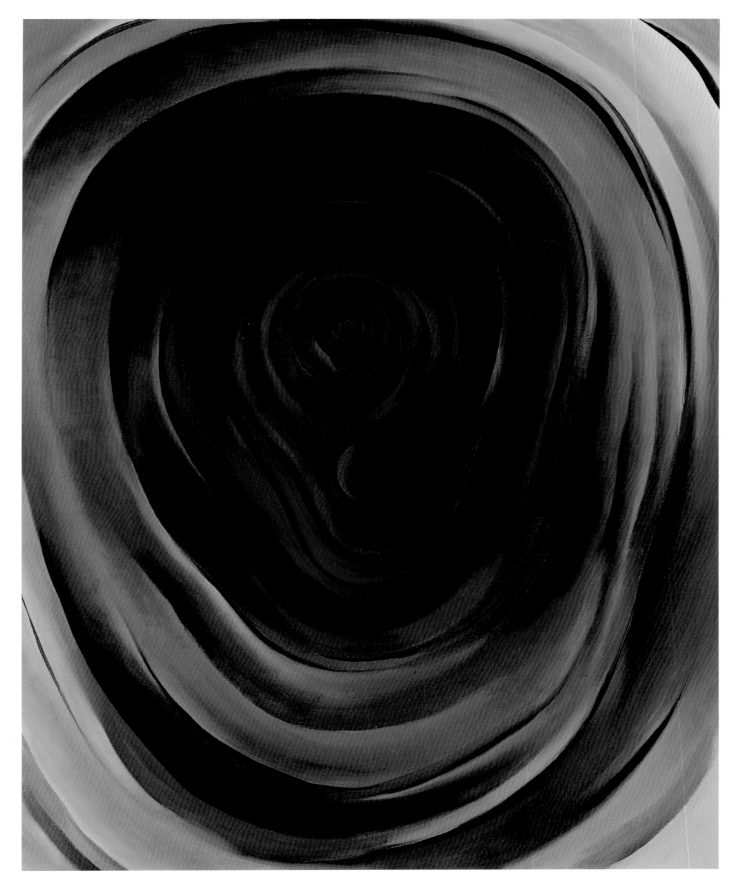

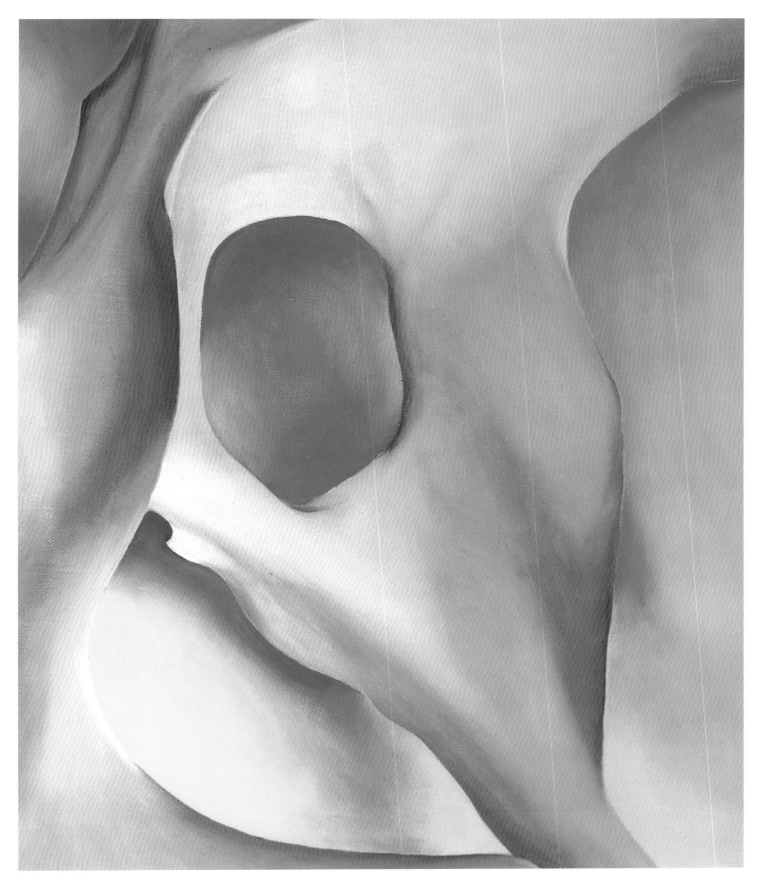

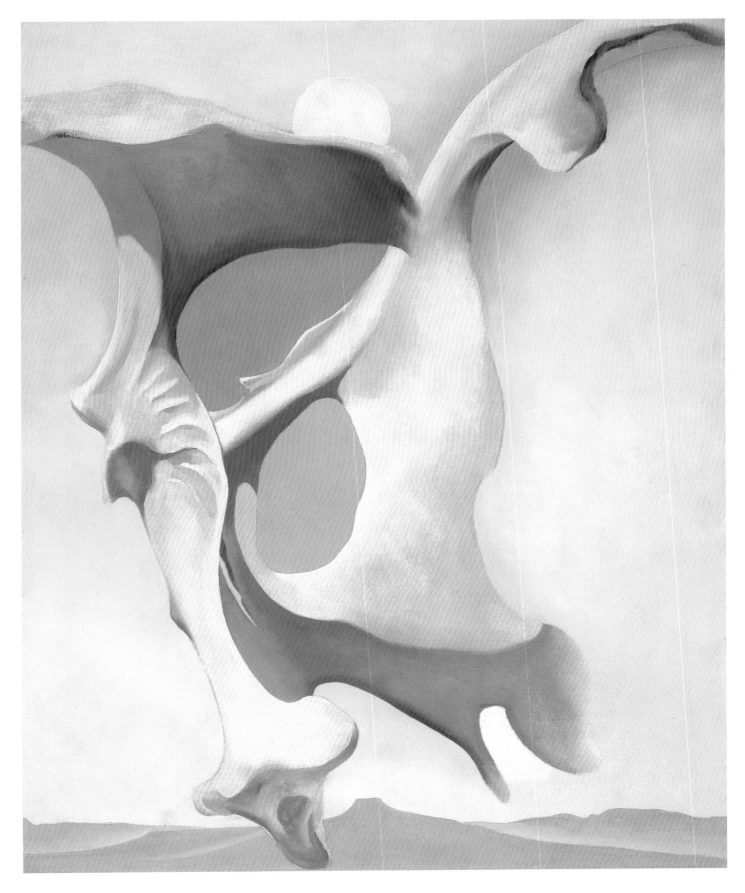

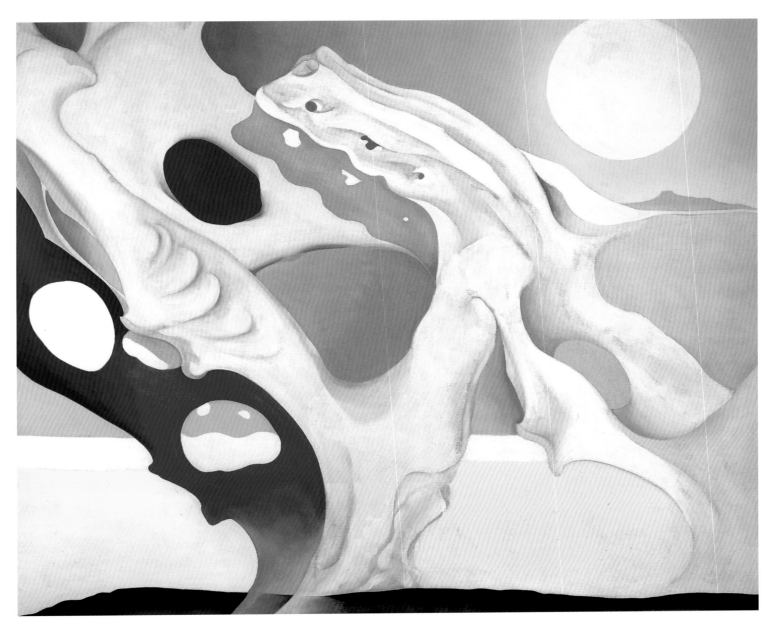

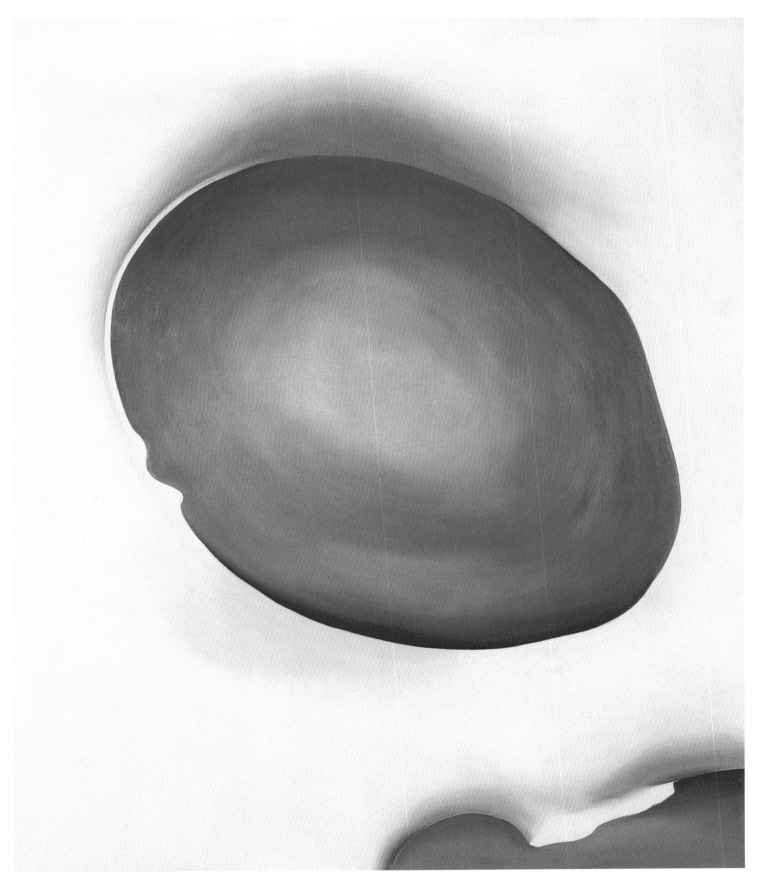

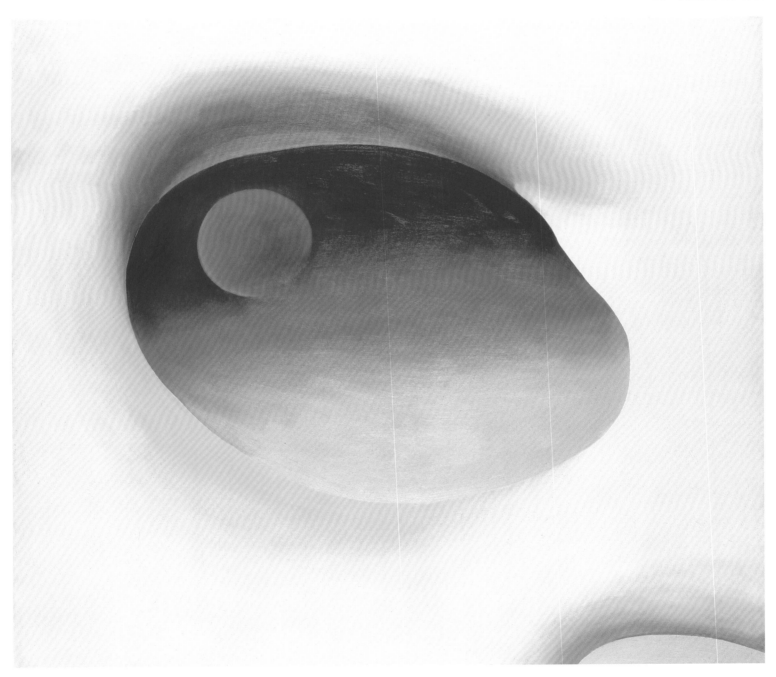

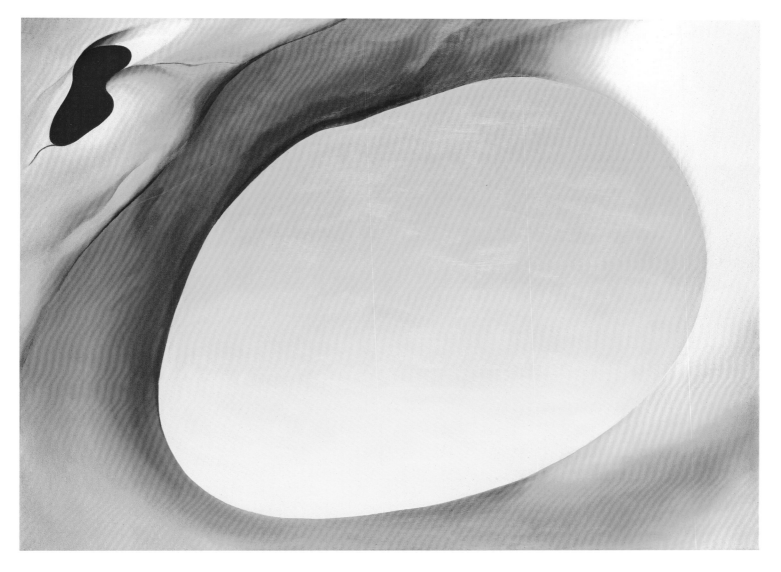

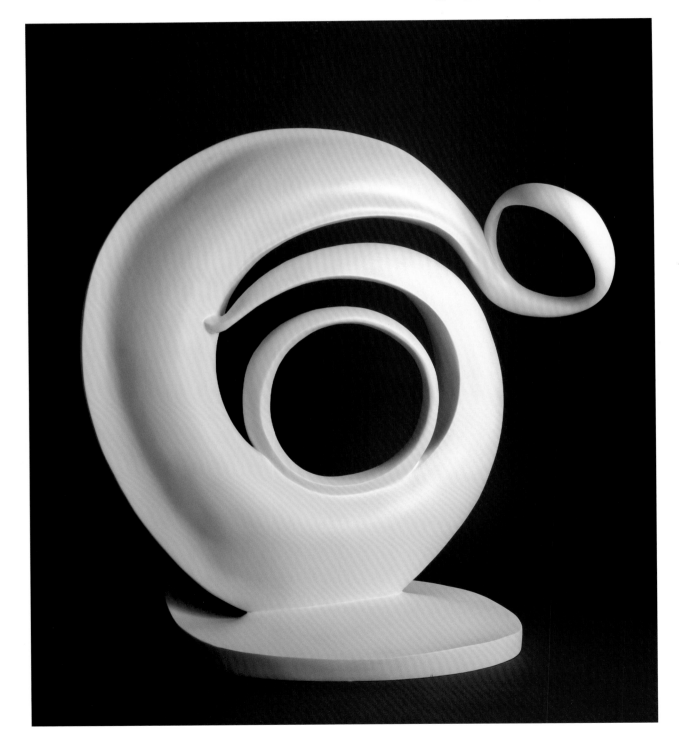

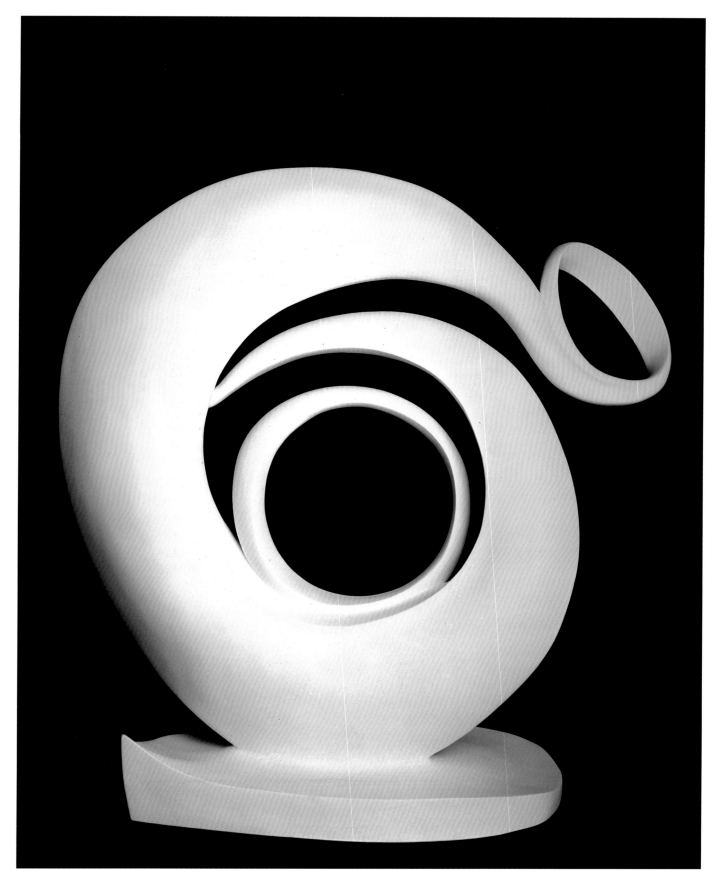

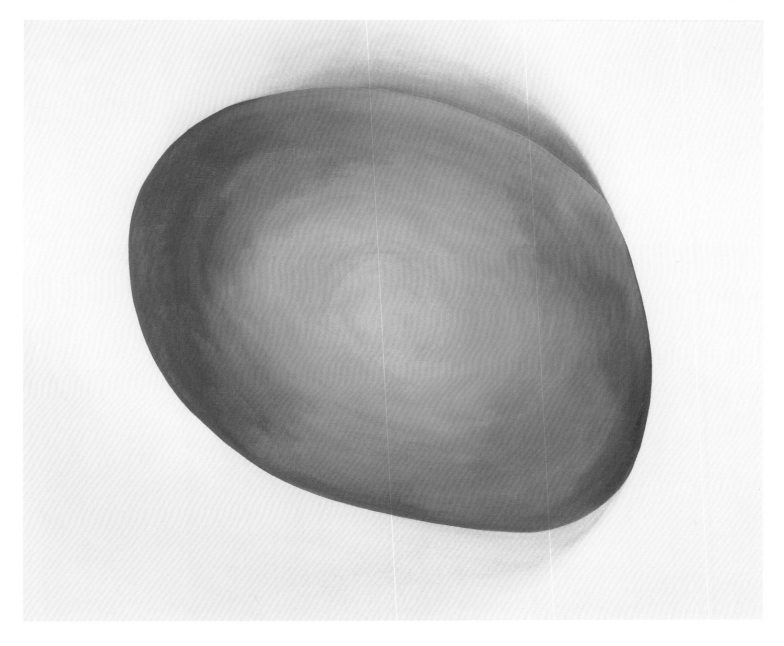

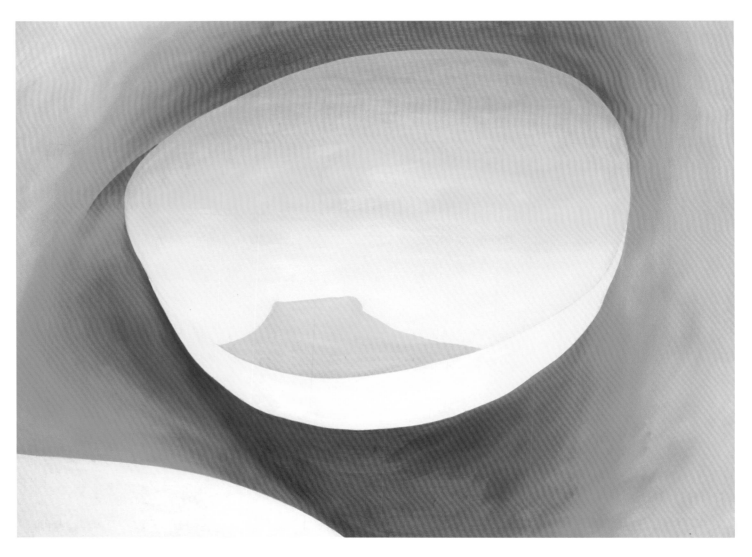

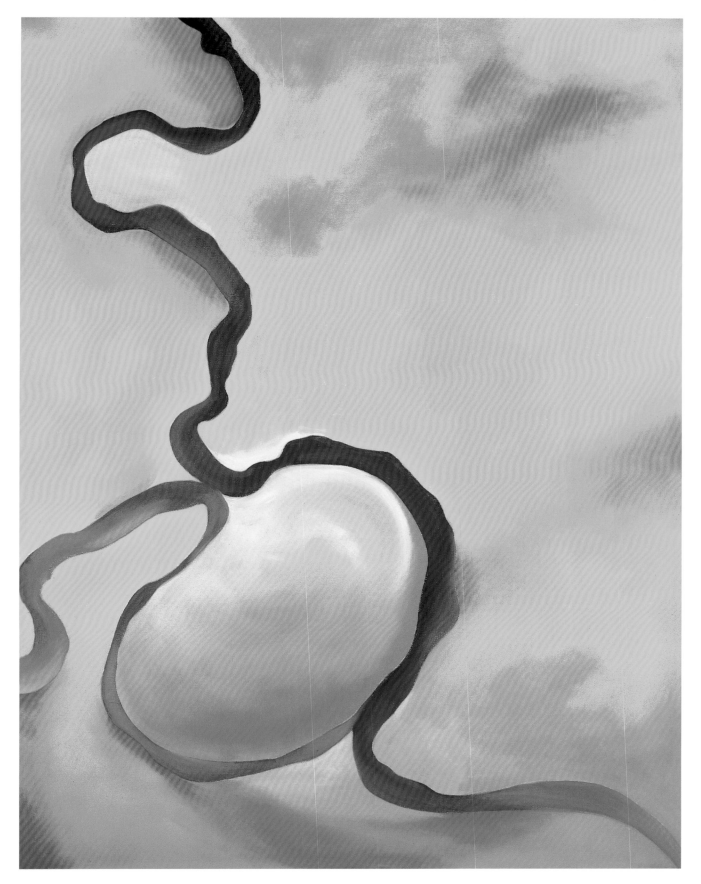

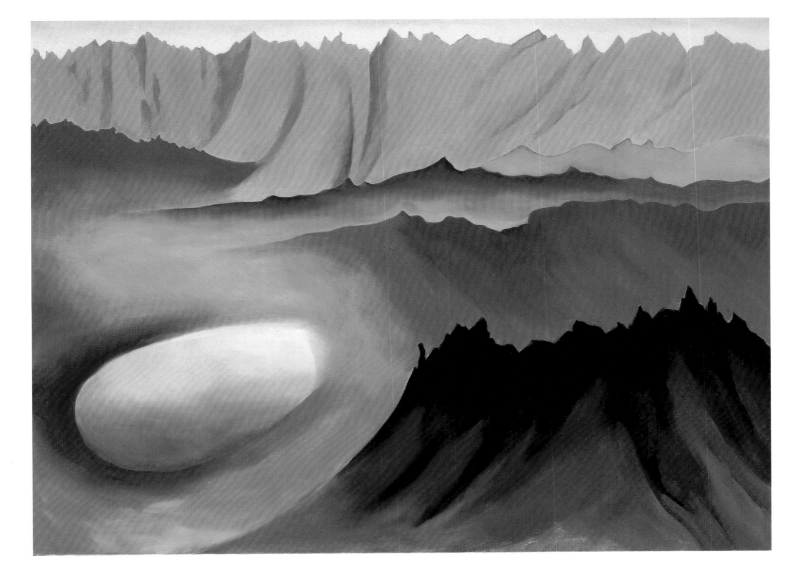

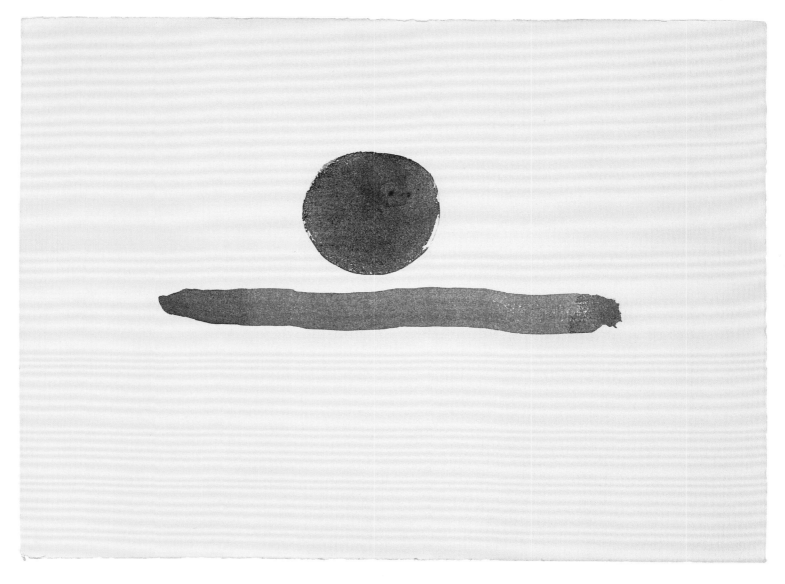

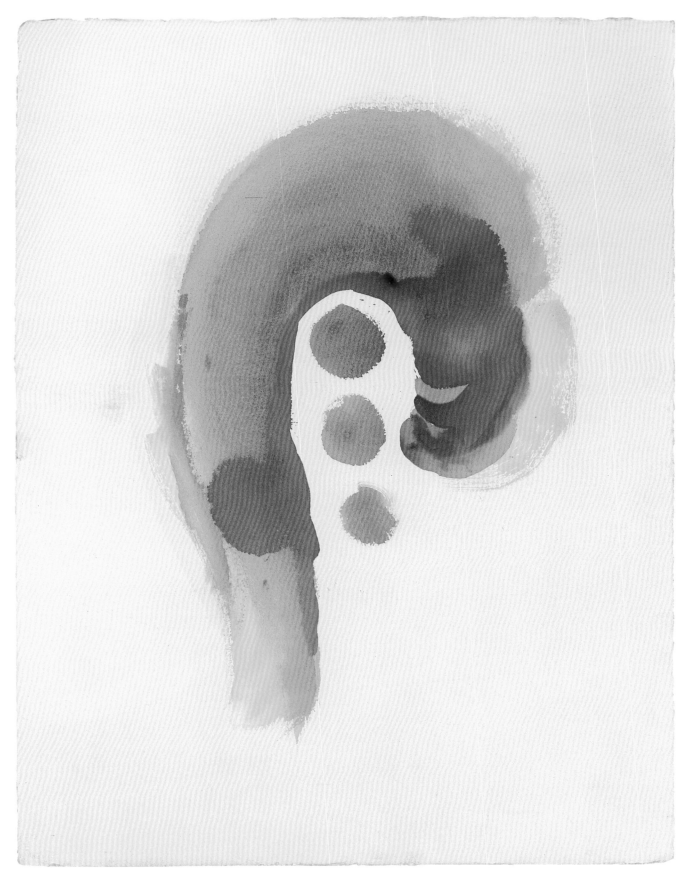

LIST OF PLATES

The following list details all works included in the exhibition. Unless otherwise noted, each work will be shown at all three venues.

1 *Drawing No. 8*, 1915
Charcoal on paper mounted on cardboard
24 1/4 x 18 7/8 inches
Whitney Museum of American Art, New York, Purchase, with funds from the Mr. and Mrs. Arthur G. Altschul Purchase Fund, 85.52
Norton Museum of Art only

2 *Early No. 2*, 1915
Charcoal on laid paper
24 x 18 1/2 inches
The Menil Collection, Houston, Gift of the Georgia O'Keeffe Foundation, 94–55

3 *No. 20–from Music–Special*, 1915
Charcoal on laid paper
13 1/2 x 11 inches
Alfred Stieglitz Collection, National Gallery of Art, Washington, Gift of the Georgia O'Keeffe Foundation, 1992.89.10
Georgia O'Keeffe Museum and The Minneapolis Institute of Arts only

4 *Blue II*, 1916
Watercolor on wove paper
27 7/8 x 22 1/4 inches
Georgia O'Keeffe Museum, Santa Fe, Gift of The Burnett Foundation, 1997.06.13

5 *Untitled (Red, Blue, Yellow)*, 1916
Watercolor on Japanese paper
17 3/4 x 13 1/8 inches
Collection of Alice C. Simkins, Texas
Georgia O'Keeffe Museum only

6 *Abstraction*, 1917
Watercolor on paper
15 3/4 x 10 7/8 inches
Collection of Gerald and Kathleen Peters, Courtesy of Gerald Peters Gallery, Santa Fe

7 *Light Coming on the Plains No. III*, 1917
Watercolor on newsprint
11 7/8 x 8 7/8 inches
Amon Carter Museum, Fort Worth, 1966.31
Norton Museum of Art and Georgia O'Keeffe Museum only

8 *Music–Pink and Blue II,* 1919
Oil on canvas
35 x 29 1/8 inches
Whitney Museum of American Art, New York, Gift of Emily Fisher Landau in honor of Tom Armstrong, 91.90

9 *Figure in Black*, 1918
Watercolor on wove paper
8 7/8 x 6 inches
Georgia O'Keeffe Museum, Santa Fe, Promised gift, The Burnett Foundation

10 *Lake George, Coat and Red*, 1919
Oil on canvas
27 3/8 x 23 1/4 inches
The Museum of Modern Art, New York, Gift of the Georgia O'Keeffe Foundation, 65.1995

11 *Red Flower*, 1919
Oil on canvas
20 1/4 x 17 1/4 inches
Norton Museum of Art, West Palm Beach, Purchase, the Esther B. O'Keeffe Charitable Foundation, 96.5

12 *Dark Red Apples & Tray No. 2*, 1920/21
Oil on canvas board
12 x 9 inches
Private Collection, Courtesy of Gerald Peters Gallery, Santa Fe

13 *Red Apple on Blue Plate*, 1921
Oil on canvas
14 x 16 inches
Collection of Donna and Marvin Schwartz
Norton Museum of Art only

14 *Green Apple on Black Plate*, 1922
Oil on canvas
14 1/8 x 12 1/8 inches
Birmingham Museum of Art, Alabama, Museum
purchase with funds from the 1983 Beaux Arts Committee,
the Advisory Committee, local donations, and funds
from Mr. and Mrs. Jack McSpadden, 1983.28

15 *Alligator Pear*, 1923
Pastel on paper
12 x 10 inches
Private Collection

16 *Fig*, 1923
Oil on canvas
7 3/8 x 5 1/2 inches
Collection of Marion Swingle

17 *Alligator Pears (Alligator Pear – No. 11)*, 1923
Pastel on paper mounted on board
12 1/4 x 10 inches
Private Collection

18 *Pink and Green*, 1922
Pastel on linen
16 x 14 inches
Collection of Mr. A. Alfred Taubman

19 *Pond in the Woods*, 1922
Pastel on paper
24 x 18 inches
Georgia O'Keeffe Museum, Santa Fe, Promised gift,
The Burnett Foundation
Norton Museum of Art and Georgia O'Keeffe Museum only

20 *Leaf Motif No. 2*, 1924
Oil on canvas
35 x 18 inches
Collection of The Marion Koogler McNay Art Museum,
San Antonio, Mary and Sylvan Lang Collection, 1975.45
Norton Museum of Art only

21 *City Night*, 1926
Oil on canvas
48 x 30 inches
The Minneapolis Institute of Arts, Gift of funds
from the Regis Corporation, Mr. and Mrs. W. John Driscoll,
the Beim Foundation, the Larsen Fund, and by public
subscription, 80.28

22 *Abstraction White Rose*, 1927
Oil on canvas
36 x 30 inches
Georgia O'Keeffe Museum, Santa Fe, Gift of The Burnett
Foundation and the Georgia O'Keeffe Foundation

23 *Black Abstraction*, 1927
Oil on canvas
30 x 40 1/4 inches
The Metropolitan Museum of Art, New York, Alfred Stieglitz
Collection, 1969 (69.278.2)

24 *At the Rodeo, New Mexico*, 1929
Oil on canvas
40 x 30 inches
Private Collection

25 *Grey Blue & Black–Pink Circle*, 1929
Oil on canvas
36 x 48 inches
Dallas Museum of Art, Gift of the Georgia O'Keeffe
Foundation, 1994.54
Norton Museum of Art and Georgia O'Keeffe Museum only

26 *Inside Clam Shell*, 1930
Oil on canvas
24 x 36 inches
Collection of Nancy Ellison and William Rollnick

27 *Dark Rocks*, 1938
Oil on canvas
15 7/8 x 19 3/4 inches
The Museum of Fine Arts, Houston, Gift of Patricia Barrett
Carter, 98.648

28 *Red and Pink Rocks*, 1938
 Oil on canvas
 18 x 13 inches
 Collection of James and Barbara Palmer

29 *Fishhook from Hawaii–No. 1*, 1939
 Oil on canvas
 18 x 14 inches
 Brooklyn Museum, New York, Bequest of Georgia
 O'Keeffe, 87.136.2

30 *A Piece of Wood*, 1942
 Oil on canvas
 24 x 20 inches
 Collection of Mr. and Mrs. Romano Vanderbes

31 *A Piece of Wood I*, 1942
 Oil on canvas
 24 x 20 inches
 Georgia O'Keeffe Museum, Santa Fe, Promised gift,
 The Burnett Foundation

32 *A Piece of Wood / From a Knot of Wood*, 1942
 Oil on canvas
 24 3/4 x 19 3/4 inches
 Collection of Kathryn Boeckman Howd and Elizabeth and
 Duncan Boeckman

33 *Pelvis–Side*, 1943
 Oil on canvas-covered board
 14 x 11 5/8 inches
 Collection of Gerald and Kathleen Peters, Courtesy of
 Gerald Peters Gallery, Santa Fe

34 *Pelvis with the Moon–New Mexico*, 1943
 Oil on canvas
 30 x 24 inches
 Norton Museum of Art, West Palm Beach, Florida,
 Purchase, the R.H. Norton Trust, 58.29

35 *Untitled (Abstraction)*, 1943
 Charcoal and chalk on paper
 24 x 17 7/8 inches
 Georgia O'Keeffe Museum, Santa Fe, Gift of the Georgia
 O'Keeffe Foundation

36 *Pelvis with Shadows and the Moon*, 1943
 Oil on canvas
 40 x 48 inches
 Private Collection, Los Angeles
 *Georgia O'Keeffe Museum and The Minneapolis
 Institute of Arts only*

37 *Pelvis with Blue (Pelvis I)*, 1944
 Oil on canvas
 36 x 30 inches
 Milwaukee Art Museum, Gift of Mrs. Harry Lynde Bradley,
 M1973.609

38 *Pelvis IV*, 1944
 Oil on Masonite
 36 x 40 inches
 Georgia O'Keeffe Museum, Santa Fe, Gift of
 The Burnett Foundation

39 *Pelvis Series, Red with Yellow*, 1945
 Oil on canvas
 36 1/8 x 48 1/8 inches
 Georgia O'Keeffe Museum, Santa Fe, Extended loan,
 Private Collection
 Georgia O'Keeffe Museum only

40 *Abstraction*, 1946 (cast 1979/80)
 White-lacquered bronze
 10 x 10 x 1 1/2 inches
 Georgia O'Keeffe Museum, Santa Fe, Gift of the Georgia
 O'Keeffe Foundation

41 *Abstraction*, 1946 (cast 1979/80)
 White-lacquered bronze
 36 x 36 x 4 1/2 inches
 Collection of Gerald and Kathleen Peters, Courtesy of Gerald
 Peters Gallery, Santa Fe

42 *Pelvis Series*, 1947
 Oil on canvas
 40 x 48 inches
 Collection of Lee and Judy Dirks

43 *Pedernal–From the Ranch I*, 1956
 Oil on canvas
 30 x 40 inches
 The Minneapolis Institute of Arts, Gift of Mr. and Mrs. John
 Cowles, 64.43.2

44 *Green, Yellow and Orange*, 1960
 Oil on canvas
 40 x 30 inches
 Brooklyn Museum, New York, Bequest of Georgia O'Keeffe,
 87.136.3

45 *Mountains and Lake*, 1961
 Oil on canvas
 30 x 40 inches
 Georgia O'Keeffe Museum, Santa Fe, Gift of the Georgia
 O'Keeffe Foundation

46 *Untitled (Landscape)*, 1960s
 Graphite on paper
 10 x 8 inches
 Georgia O'Keeffe Museum, Santa Fe, Gift of the Georgia
 O'Keeffe Foundation

47 *Untitled (Landscape)*, 1960s
 Graphite on paper
 6 1/2 x 8 3/4 inches
 Georgia O'Keeffe Museum, Santa Fe, Gift of the Georgia
 O'Keeffe Foundation

48 *Untitled (Abstraction Blue Circle and Line)*, 1976/77
 Watercolor on wove paper
 22 1/2 x 29 7/8 inches
 Georgia O'Keeffe Museum, Santa Fe, Gift of the Georgia
 O'Keeffe Foundation

49 *Untitled (Abstraction)*, 1970s
 Charcoal on paper
 24 x 17 3/4 inches
 Georgia O'Keeffe Museum, Santa Fe, Gift of the Georgia
 O'Keeffe Foundation

50 *Untitled (Abstraction Orange and Red Wave)*, 1970s
 Watercolor on paper
 30 x 22 inches
 Georgia O'Keeffe Museum, Santa Fe, Gift of the Georgia
 O'Keeffe Foundation

51 *Untitled (Abstraction Pink Curve and Circles)*, 1970s
 Watercolor on paper
 30 1/2 x 22 inches
 Georgia O'Keeffe Museum, Santa Fe, Gift of the Georgia
 O'Keeffe Foundation